IMAGES
*of America*

# SMARTSVILLE AND
# TIMBUCTOO

D1572411

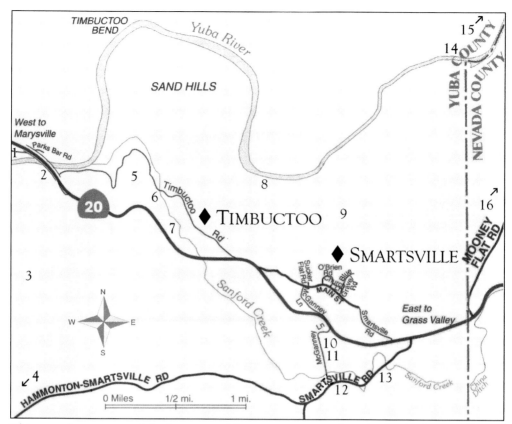

This map shows many of the features and locations mentioned in this book. Smartsville and Timbuctoo are in eastern Yuba County, roughly 15 miles east of Marysville and 15 miles west of Grass Valley. Highway 20 meets the old road briefly between Timbuctoo and Smartsville. Note that Mooney Flat is in Nevada County. The following locations are marked: 1. Parks Bar, 2. Parks Bar Bridge, 3. Bonanza Ranch, 4. Beale Air Force Base, 5. Timbuctoo Cemetery, 6. Timbuctoo Bridge, 7. Timbuctoo Ravine, 8. Roses Bar, 9. Sucker Flat, 10. Smartsville Catholic Cemetery, 11. McGanney Cemetery, 12. Smartsville Masonic Cemetery, 13. Empire Ranch, 14. The Narrows, 15. Englebright Reservoir, and 16. Mooney Flat. (Map by Lane Parker.)

IMAGES
*of America*

# SMARTSVILLE AND TIMBUCTOO

Kathleen Smith and Lane Parker

ARCADIA
PUBLISHING

Published by Arcadia Publishing
Charleston, South Carolina

Printed in the United States of America

Library of Congress Control Number: 2007935824

For all general information, please contact Arcadia Publishing:
Telephone 843-853-2070
Fax 843-853-0044
E-mail sales@arcadiapublishing.com
For customer service and orders:
Toll-Free 1-888-313-2665

Visit us on the Internet at www.arcadiapublishing.com

*To pioneer men, women, and children, past, present, and future.*

# CONTENTS

Acknowledgments      6

Introduction      7

1.    Before Smartsville and Timbuctoo      9

2.    Timbuctoo: The Most Populace Place      23

3.    Timbuctoo: Relics of Pioneer Days      47

4.    Mining Smartsville and Timbuctoo      65

5.    Smartsville: Gem of the Foothills      83

6.    Smartsville: Days Gone By      103

Selected Bibliography      126

Index      127

# ACKNOWLEDGMENTS

Many people helped us during our research for this book. Here we want to thank those who were especially giving of their time and resources: Evelyn and Brad Allis; Leanna Beam; John Black at KUBA Radio; Kit Burton of the Smartsville Church Restoration Fund; Sue Cejner-Moyers; Dr. Robert Chandler; Mary Clark; Nora Compton; Bill Conlin; Kara and James Davis at Amicus Books; Henry Delamere; Kathy Donovan; Rosemary Freeland; Harriet Galligan; Christine Gillespie at the *Rabbit Creek Journal*; April Hennes and the rest of the staff at the Yuba County Library; Tammy Hopkins at Marysville Posterworks; Patricia Keats, librarian, and Adriane Tafoya, registrar, at the Society of California Pioneers; Dylan McDonald at the Sacramento Archives and Museum Collection Center (SAMCC); Helen McGovern; Marianne McKnight at the *Penn Valley Courier*; Charles Miller at the National Archives and Records Administration (NARA) Pacific Region; John Mistler at the *Territorial Dispatch*; Bill Peardon; Cletius Rogers; Dan Brooks, Alan Murray, Chief Curtis Mills, and Chris Turner at the Smartsville Fire Protection District; Peppie Schrader, president, and Erin Gillespie, historian, at the Mary Aaron Memorial Museum; Susan Snyder; Coralina Vance; Ron Yerxa; and Trisha Ziff.

We would also like to thank our editors: Devon Weston, for giving us the chance to create this book; and Kelly Reed, for her help and hard work. We also appreciate the work of production editors Barbie Halaby and Rob Kangas.

Kathleen would also like to thank Janett, Phillip, Michelle, Seth, and Madeline for their support and for understanding her preoccupation with this project; Edward and Eddie Smith for the inspiration to pursue the subject; her new friend Lane Parker for inviting her along on this adventure and for his faith in her ability; her friend John Crandall for being the perfect example of how anyone can do anything they set their mind to; and all of her friends and extended family members for their encouragement.

Lane would like to thank Cheryl Yerxa and Brenda Pedersen. Additionally, he would like to thank Kathleen Smith for her friendship and tireless efforts. Above all, he would like to thank his wife, Stacey Hunter, for her support, assistance, and encouragement throughout this project.

Kathleen and Lane also extend their deepest thanks and gratitude to Kathy Sedler, without whose help and support the book you hold in your hands you would not be holding in your hands.

# INTRODUCTION

While rolling along the narrow main street through Smartsville or Timbuctoo, a modern-day visitor to this lonely-looking locale might think of Gertrude Stein's famous comment about Oakland: when you get there, "there's no there there." Yet every place, no matter how small or isolated, has a past and a story, and even though today there is not much "there there," Smartsville and Timbuctoo occupy an important place in California's rich and colorful Gold Rush history and may still play a role in the state's future development.

Smartsville and Timbuctoo, though each has its own name, are essentially the same place, inextricably intertwined. Both are former Gold Rush boomtowns whose roots reach back to the outlying river camps of Parks Bar and Roses Bar. During 1849, California's Gold Rush had led first hundreds and then thousands of prospectors to collect along the Yuba River in eastern Yuba County at places such as Parks Bar, Roses Bar, and Empire Ranch. A tent settlement called Sand Hill began up off of the bars in 1850. By 1853, Sucker Flat (originally Gatesville) had a population of 300. Mooney Flat was established in 1855, and by that same year, most of the inhabitants of Sand Hill had moved south across to the next high ground, to a place called Timbuctoo. Neighboring Smartsville (an outgrowth of the original Empire Ranch) was established by 1856. By about 1860, according to contemporary accounts, Timbuctoo was the largest and most populace place in eastern Yuba County.

Men and women arrived from Europe, most notably Ireland, adding to the Native Americans and Californios already in the region. Immigrants from the eastern United States and China followed. In those boomtown days, Smartsville and Timbuctoo were home to everyone, not only dreamers but also desperate souls and rogues and rascals. Black Bart stalked the stage routes, leaving "poems" at each of his robbery scenes. On one infamous occasion in 1855, Jim Webster, the "Timbuctoo Terror," shot three men dead, creating the need for the first cemetery in Timbuctoo. Observers and reporters such as Noah Brooks, Mark Twain, and Brett Hart made regular stops in the region. The place also played a role in the famous 1884 Sawyer decision, which in large part put an end to the destructive hydraulic mining begun in the mid- to late 1800s: many of the nearly 2,000 expert witnesses, who gave affidavits and testimony in *Woodruff v. North Bloomfield Gravel Mining Co.*, lived in the Smartsville and Timbuctoo region.

There are so many versions of the origins of Timbuctoo's name that it is unlikely anyone will ever be able to solve the mystery. Newspapers always have had trouble with even the spelling, rendering the name Timbuctoo, Timbuctu, Timbuktu, and Timbucktoo. Smartsville is unarguably named after James Smart, who built the first hotel there in 1856; however, a debate still continues (among non-locals) whether the place should be called Smartsville, with an "s" in the middle, or simply Smartville. Often contemporary newspapers hedged their bets by calling it "Smart(s)ville" in their articles.

When Timbuctoo lost its post office and school, both institutions were relocated to and combined with those in Smartsville. (Timbuctoo's schoolhouse was physically moved up the road to Smartsville.) One specific example of the connection between Smartsville and Timbuctoo is

this: in 1892, Phillip Smith, the son of Timbuctoo residents Matthew and Bridget Smith, married Bessie, daughter of John and Elizabeth Peardon, owners (and residents) of the Smartsville Hotel in neighboring Smartsville.

The connection between the different "camps" continued. At one point, a friendly rivalry arose between Lyman Ackley, a staunch supporter of Smartsville, and William Craney, a Sucker Flat booster. Each competed to make his town number one. Ackley said he would "see grass grow on the street of Sucker Flat." And it does today. More recently, Smartsville native and lifelong resident George Rigby, the "Sage of Smartsville," has had his stories compiled into the volume *He Made a Saddle and Wrote a Book*. Other area residents and boosters include William "Wild Bill" Gruber and Matthew McCarty, the "Mayor of Timbuctoo," both caretakers of the old Wells Fargo Building in Timbuctoo.

Today the original settlement of Roses Bar is completely covered by slickens from the hydraulic mining operations. Timbuctoo is less populated than Smartsville—and even its one claim to fame, the Wells Fargo Building, is no more than a burnt-out pile of brick and metal. Smartsville, however, retains its post office and a fire station, and plans are still alive to restore the historic Church of the Immaculate Conception.

The area is still mainly rural, with residents commuting to Marysville or other bigger towns nearby. Nordic Industries operates aggregate operations along the Yuba River outside of Timbuctoo, producing Yuba Blue gravel. Smartsville still houses a post office, fire department, and U.S. Department of Forestry substation. And both towns have seen efforts to restore their historic structures—with differing success. At one point, in the late 1950s, the only people working to save the Wells Fargo Building at Timbuctoo were Sam O. Gunning Jr., of Timbuctoo, and Asa Fippin, of Smartsville.

Following in the tradition of Gunning and Fippin, small but dedicated groups of volunteers are working to restore the Roses Bar School and the Church of the Immaculate Conception in Smartsville. And plans are currently underway to re-create the area as a historic tourist destination. Other groups, like the non-profit Yuba River Preservation Foundation, are dedicated to conservation and preservation of a different kind. The YRPF is currently trying to save the local osprey and bald eagle populations as well as the wild Chinook salmon that run between Parks Bar Bridge and Englebright Dam to the north.

Property around Timbuctoo continues to be subdivided, and some local residents are already seeing signs of the area becoming a bedroom community for long-distance commuters. Across the Yuba River to the north, a golf course stretches green against the dun-colored country. For the first time in a long time, area residents contemplate the arrival of a new wave of immigrants, this time from Sacramento and even the Bay Area. Plans to reconstruct Smartsville and Timbuctoo as popular tourist spots, like Nevada City and Grass Valley, no longer seem like impossible dreams. One day soon, the place known as Smartsville and Timbuctoo might be rediscovered, reimagined, and perhaps even reconstructed—evidence that, even though a place might look dead and gone, it has a past, a story to tell, and perhaps even a future.

# One

# BEFORE SMARTSVILLE AND TIMBUCTOO

In the foothills of eastern Yuba County, Native Americans had lived undisturbed for centuries, combining both farming and hunter-gatherer methods. In 1821, after Mexican independence, large ranchos were created and wealthy landowners were trading with and using the Native Americans as laborers. In early 1848, Jonas Spect left Yerba Buena (what it was then called before being renamed San Francisco), deciding to head back East and "home." While waiting near Sacramento to gather enough men to make the trip, Spect, acting on a hunch, decided to try prospecting. He spent a night in Timbuctoo Ravine, and the next day, a Native American guide led him up to what would later be called Roses Bar. Here he "met a large number of Indians, all entirely nude and eating clover." On June 2, 1848, just above Timbuctoo Ravine, Spect "washed some of the dirt and found three lumps of gold worth about seven dollars." This started the rush for gold in Yuba County. A few years later, the region's original inhabitants were still playing a role. H. T. Craig wrote from Roses Bar that the Native Americans "were almost in a brute state of nature when the whites came to this country, but they are learning the English Language with a mixture of Spanish. . . . I expect you would be amused to heare me talking the Indian Language of this country, which is very difficult to learn, but very simple when learned." Some prospectors, such as Jonas Spect and David Parks, made their piles and returned to their former lives back East, while others, such as John Rose and Thomas Mooney, stayed to build on the foundations they had made. John Rose, who had recently bought land in eastern Yuba County, was building a mill for Gen. Mariano Vallejo when Spect first found gold. Rose joined others in the rush to the bar that would later bear his name. A few years later, in 1851, Mooney bought land in the hills nearby and created Empire Ranch.

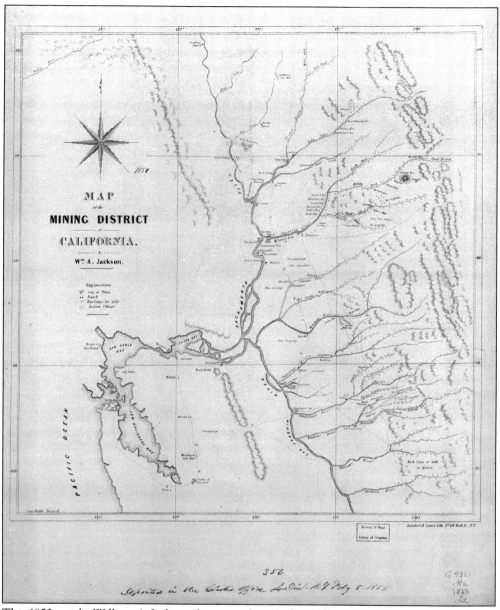

This 1850 map by William A. Jackson shows ranches, "Indian Villages," and the few mining camps on the Yuba River at the time. Also mapped is the John Rose and William Reynolds settlement later named Roses Bar. Rose and Reynolds began as partners but dissolved their partnership to pursue different opportunities. (Courtesy Tammy L. Hopkins.)

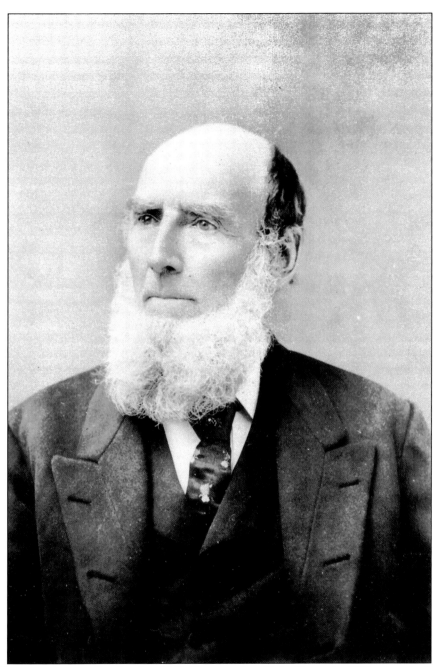

John Rose was born in Scotland in 1817. He arrived in Yerba Buena in 1839 where he became the city's first treasurer. After making Roses Bar his home, Rose served his community on various boards and committees. He married and was the father of six children. In 1891, he was invited to the Admission Day celebration. A few years before his death, he attended the Native Sons of the Golden West celebration in San Francisco, where he was recognized as one of the oldest living California pioneers. Imagine what a transformation he must have seen since he first arrived in Yerba Buena. He remained in Smartsville until his death in 1899. This photograph was taken in 1887. (Courtesy Yuba County Library.)

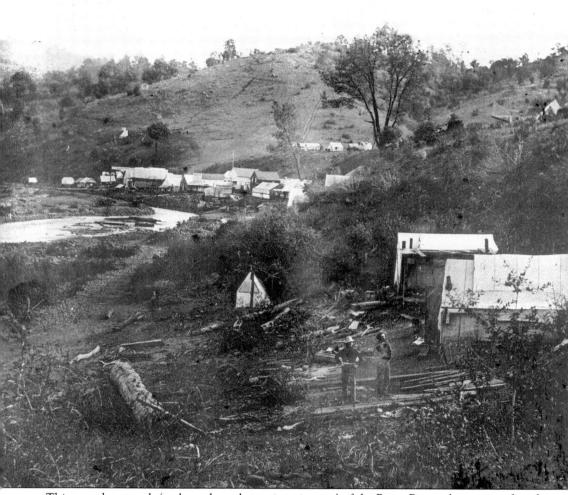

This rare photograph (perhaps the only one in existence) of the Roses Bar settlement was found by the great-grandson of Benjamin Marshall Sawin, one of the founding members of the Roses Bar Lodge. Sawin later returned to Massachusetts, claiming that all he got in California was mud and blisters on his hands. The settlement was short-lived—it flooded too often—and most of the buildings were moved half a mile up the hill to Empire Ranch (later called Smartsville). Still, decisions made at the lodge meetings in Roses Bar affected the development of California and consequently the United States. At one meeting, a resolution was passed that prohibited slave owners from having slaves work their claims, nor could the owners file claims in the names of their slaves. At another meeting, anti-slavery representatives were elected to the state constitutional convention, which contributed to California's admittance as a free state, in turn affecting the outcome of the Civil War. (Courtesy Bill Fuller.)

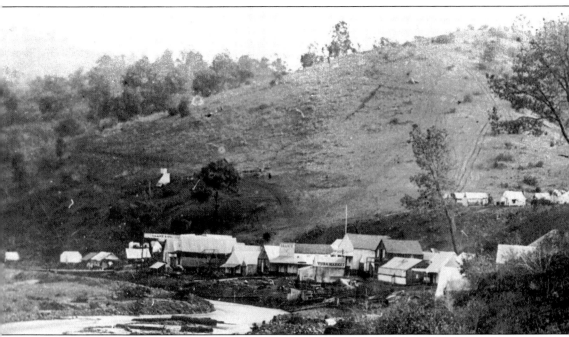

As the miners began to arrive from the East, Roses Bar became very crowded. In the spring of 1849 at a miners committee meeting, held at the Branch Saloon, the decision that a claim should be 100 feet square and that miners should be confined to their claim was made. In 1850, there were 2,000 men working there. The Branch Saloon, the Masonic Hall that was eventually moved to Smartsville, and other buildings can be identified in the foreground. In a letter to his sister back East from Roses Bar on November 11, 1851, H. T. Craig wrote, "Dear Em. . . . This is truthfully one of the most heathen countries that I was ever in." But he admitted, "Em it would astonish you to see the money that is made in this country." It was not long before hydraulic mining began and Roses Bar was completely covered by the tailings and mud. (Courtesy Bill Fuller.)

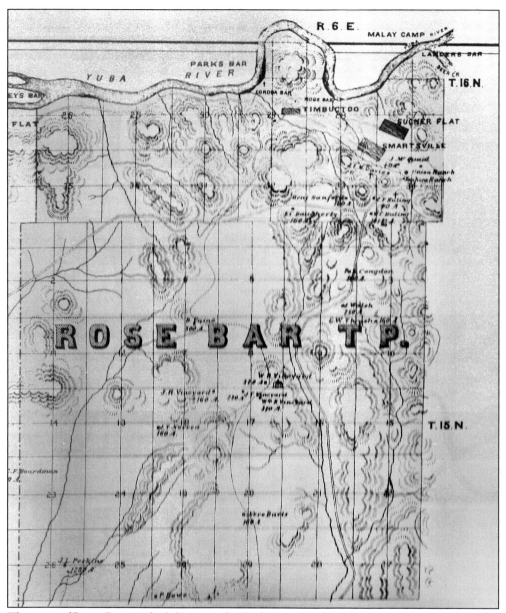

The town of Roses Bar supplied the name for the larger township. As seen on this map from the Thompson and West volume *History of Yuba County, California with Illustrations*, most of the settlements lie on the township's northern edge, along the Yuba River, and include Roses Bar, Timbuctoo, Sucker Flat, Empire Ranch, and Smartsville. (Courtesy Yuba County Library.)

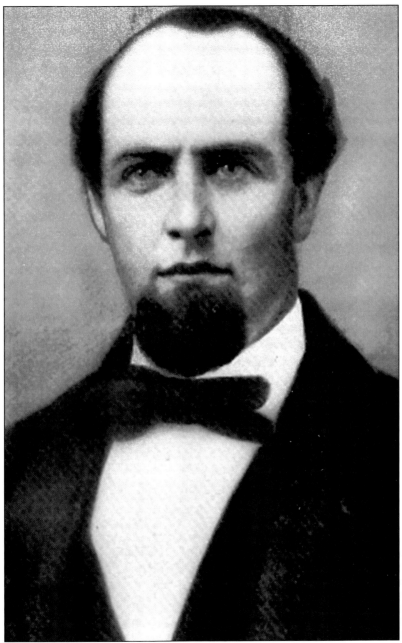

Thomas Mooney purchased milk cows and a hen and rooster from the previous owners of his ranch, who had brought them across country. On Sundays, miners gathered at Empire Ranch to have a festival. A feast of beef and accompanying foods and alcoholic beverages were served. He sold roosters to the miners for shooting contest prizes. Mooney said, "Why I could no more count up the money those chickens and cows made for me than I could fly. Taking what I received for the young chickens, the eggs, the barrels of milk punch and other goods I sold to those who came to see the shooting matches, for instance, directly or indirectly I made thousands of dollars." Mooney, a native of Ireland, married Mary Hulling, and together they had eight children. After Mooney's death, his children all remained living at Empire Ranch. (Courtesy YubaRoots.)

At one point, Empire Ranch was reportedly the most important settlement in the area. There Thomas Mooney raised cattle, built a hotel, opened the first post office in the area, established a trading post, and began a stage line from Marysville to Grass Valley. This photograph shows Empire Ranch around 1910. Just left of center is the side of the hotel, to the left of that the blacksmith's shop, and to the right the barn and stable. The location is just off of Smartsville Road. (Courtesy California Historical Society.)

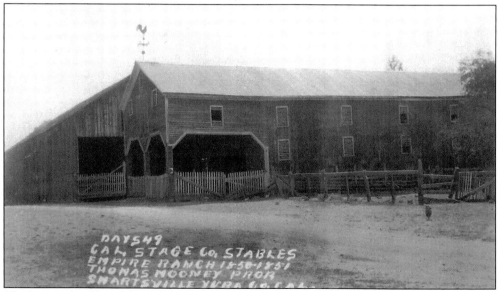

The barn and stables of the California Stage Company at Empire Ranch were part of a booming transportation industry supporting the continued growth and development of the Roses Bar area. (See page 90 for an advertisement for the company.) Could the rooster standing in the foreground possibly be a descendant of the original pair purchased by Thomas Mooney and known as the "Pioneer Chickens of the County"? (Courtesy California Historical Society.)

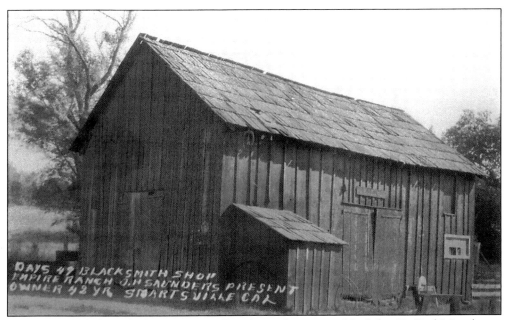

The original blacksmith shop at Empire Ranch was later owned by John H. "Jack" Sanders, a native of Smartsville. At age 11, Sanders did odd jobs for a blacksmith from the Pactolas Mine. This blacksmith taught Sanders his trade, and Sanders was so grateful for the training that he later said he would never run a boy off from his anvil. Sanders practiced his wagoner and farrier crafts for nearly 50 years. (Courtesy California Historical Society.)

The Empire Ranch House and Hotel appears to have been a comfortable place. The materials for the buildings were brought around Cape Horn from the East—an expensive but common practice: many of the people who immigrated to the gold fields came from the East and were used to the finest items and most modern technology. (Courtesy California Historical Society.)

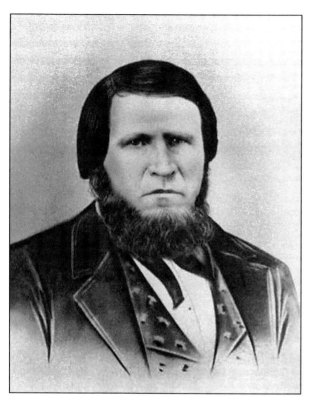

David Parks was born in Pennsylvania in 1805. Having farmed in Ohio and Indiana, he decided in 1848 to move his family to Oregon. On the way, he heard about the discovery of gold in California and changed his plans. He arrived at the Yuba River in September 1848 and began mining and running a store. In 1851 or early 1852, he and his wife, Catherine, left what had become the thriving settlement of Parks Bar to return to farming in Indiana. (Courtesy Tammy L. Hopkins.)

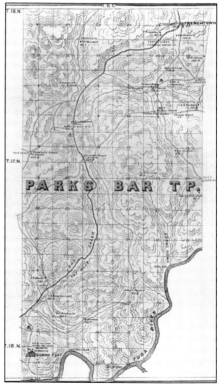

This map of Parks Bar Township is from the Thompson and West volume *History of Yuba County, California with Illustrations*. Both Parks Bar Township and Roses Bar Township were redrawn several times over the years. Today the townships are on opposite sides of the Yuba River from each other. In 1850, several small companies built dams on the Yuba from Roses Bar to Parks Bar in attempts to mine the riverbed. The dams always failed but not before the miners had mined enough gold to justify their efforts. (Courtesy Yuba County Library.)

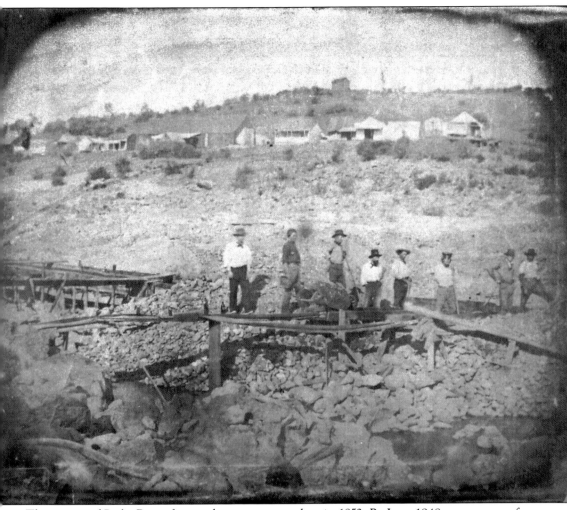

This image of Parks Bar is from a daguerreotype taken in 1852. By June 1948, a company of Benicia prospectors was working the bar, though the men left a short time later, having decided that the claim did not pay enough. By early 1849, however, miners were collecting at the bar, and all of them apparently made their piles, creating a thriving town in the process. In 1852, there were an estimated 800 people and the town boasted, among numerous saloons, a post office, barbershop, two blacksmith shops, three hotels, and six general stores. The population began to wane by 1855, and by 1879, according to Thompson and West, "The muddy waters of the Yuba now flow over the old site of this once flourishing town, and but little is left to bear evidence of its former prosperity." (Courtesy California Historical Society.)

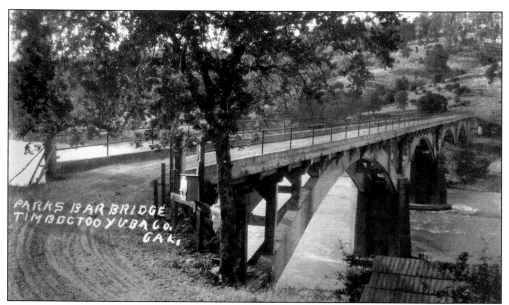

At first, ferries provided access across the Yuba River at Parks Bar. Construction of the first bridge began in 1851, but flooding destroyed the structure before its completion. Other bridges built in 1853, 1859, and 1862 suffered similar fates. By 1879, transportation was reduced to a skiff ferry. The Parks Bar Bridge, pictured here around 1920, was designed in 1912 and completed in 1913. It was 684 feet long and 16 feet wide. In 1924, the bridge was widened to 22 feet. (Courtesy California Historical Society.)

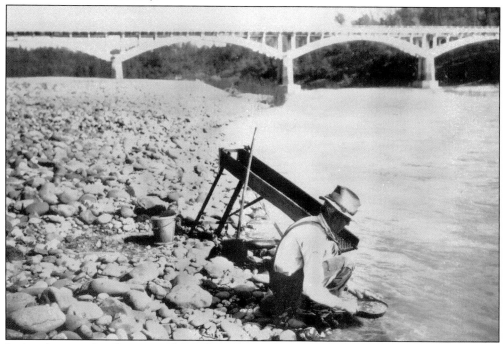

In this photograph, a "prospector" pans for gold at Parks Bar on the Yuba River in 1932. "This spot is reached after a scenic drive over good highway," boasted regional promotional literature. "Here the visitor is allowed the privilege of panning for his own gold." (Lane Parker collection.)

Pictured is the Parks Bar Bridge in the late 1980s. Visible through the trees are two of the bridge's four 140-foot-long arch spans. In 1986, the structure was determined eligible for the National Register of Historic Places. Over the years, the lowering riverbed undermined the footings, and in 1994, the bridge was torn down once a new bridge had been completed downriver. (Photograph by Laverne E. Denyer.)

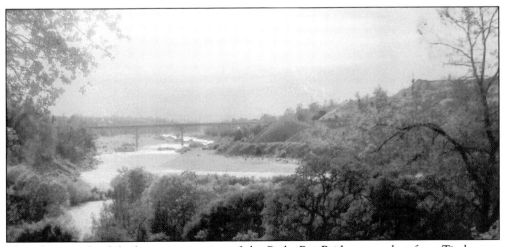

This photograph of the latest incarnation of the Parks Bar Bridge was taken from Timbuctoo Road in 2007. Aggregate operations of Nordic Industries are visible across the Yuba River to the right. (Photograph by Lane Parker.)

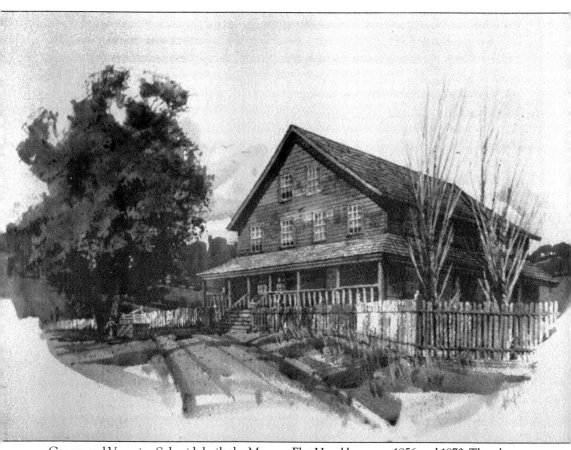

George and Veronica Schmidt built the Mooney Flat Hotel between 1856 and 1870. The place was originally called the Live Oak Hotel for the large oak that stood in front, then later also known as the Schmidt Hotel. In the early years, it was a stop for large teams. It had accommodations for the teams, teamsters, and traveling guests. Women and children entered to the right, into the main hall, while the men went to the left into a well-stocked bar. The second floor contained bedrooms with spring beds and a ballroom. The third floor held bunks for teamsters and miners. The hotel was also a gathering place for locals. The Schmidt family ran the hotel for over 100 years. In later years, the place became a family vacation spot. (Courtesy Mary Clark.)

*Two*

# TIMBUCTOO
## THE MOST POPULACE PLACE

By 1850, miners had begun working back from the river bars and into the ravines and hills. On a hill just north of what would later be called Timbuctoo, miners began erecting tents and wooden buildings, and the site became known as Sand Hill. But with the introduction of hydraulic mining, miners found that Sand Hill was rich ground; consequently most everyone began moving slightly south across a ravine to Timbuctoo in order to mine Sand Hill.

"By 1856," according to Thompson and West, "they had all but left the old locality." Timbuctoo, however, was just coming into its own. A ravine had already been given the name "Timbuctoo." The West African city of Timbuktu (or Tombouctou) was famous for its trade in copper, salt, and gold. So it seems completely fitting that the Argonauts, who were "going to see the elephant," would name a ravine and later a boomtown after not only the legendary African city of gold but also what by that time had become a figurative term to mean any mysterious, faraway place. And the origin of the boomtown's name is as mysterious as its distant cousin on the Dark Continent. According to some accounts, the first white miners in the area found an African already at work "with pick and pan" and decided to name the place Timbuctoo. According to another version, William Marple, a Roses Bar storekeeper and part-time gold miner, suddenly found himself making more from his claim than from his full-time business, after which point he became known as "the Sultan of Timbuctoo."

Contemporary newspaper editors, writing stories about the town, apparently have been mystified by the actual spelling of the place, rendering it in headlines as Timbucktoo and Timbuctu, among other variations.

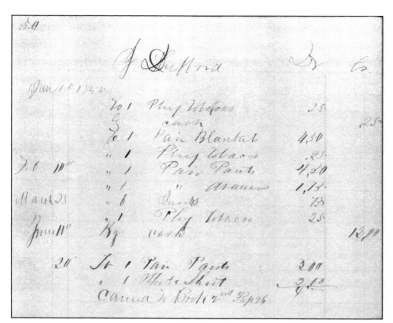

Jacob Dufford was a carpenter born in New Jersey. In February 1855, at age 27, he finished building the first hotel in Timbuctoo. This page from David Gregory's 1855 store ledger records some of Dufford's purchases. (Courtesy Yuba County Library.)

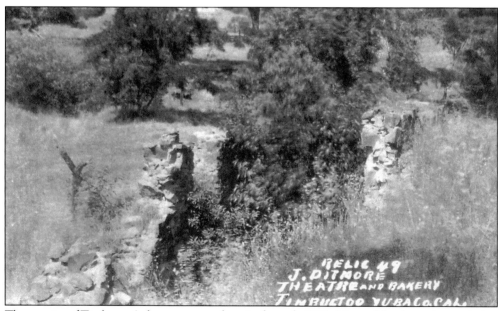

The remains of Timbuctoo's theater are seen here in the early 1900s. News of the theater's completion in November 1857 made the San Francisco papers. Built entirely of wood except for its brick basement, the house seated 800 people for performances by both local and touring companies. In the early 1860s, politicians gave speeches there. After Timbuctoo's only church was torn down and rebuilt as a barn in 1878, the theater also served as a place for more sacred gatherings. In late 1889, Roses Bar Lodge Number 89 of the Free and Accepted Masons met at the theater "to perform the rite of burial of G. N. Canfeild." Later, according to Thompson and West, Chinese immigrants lived in the "old ruin" of the theater. (Courtesy California Historical Society.)

# WELLS, FARGO & CO'S EXPRESS.

Value, $ *3 7 5*   *Aug 13* 18*60*

Received of *J. D. Rose*

One   Package   *Gold Coin*

Addressed *W. S. Millard, Sacramento*

which we agree to forward to *him*

and deliver *promptly*

In no event to be liable beyond our Route as herein receipted. It is further agreed, and is part of the consideration of this contract, that WELLS, FARGO & Co. are not to be responsible except as forwarders, nor for any loss or damage arising from the dangers of railroad, ocean or river navigation, fire, etc., UNLESS SPECIALLY INSURED BY THEM, AND SO SPECIFIED IN THIS RECEIPT.

For the Proprietors,

Charges, $ *75 ¢*

Towne & Bacon's Print, San Francisco.

In 1860, the Wells Fargo and Company office in Timbuctoo had been open for five years when John Rose paid 75¢ for the company to deliver one package of gold coin "promptly" to W. S. Millard in Sacramento. (Courtesy California Historical Society.)

This detail of N. Wescoatt's 1861 *Official Map of Yuba County* shows northern Roses Bar Township and southern Parks Bar Township. To the west, near the Yuba River, is the "Cemetery of 1849 & 1850," and across Roses Bar to the north is a site containing "Three Graves." Timbuctoo's official town cemetery began in 1855, when citizens buried three men killed by Jim "The Timbuctoo Terror" Webster, who perhaps shot the men during a mining claim dispute. The cemetery was fenced in 1857. (Courtesy California State Library.)

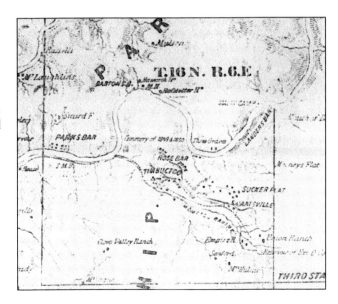

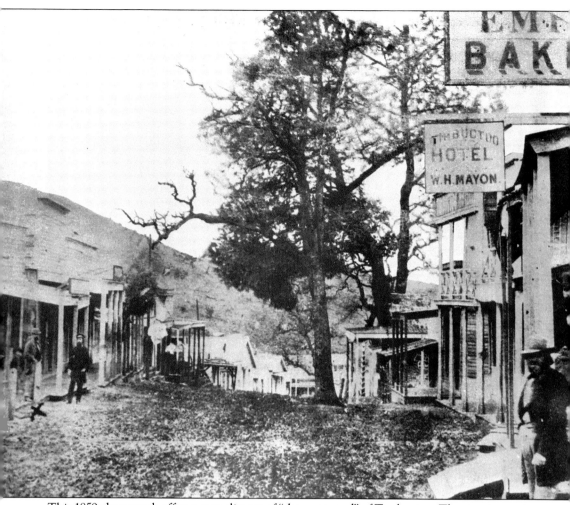

This 1859 photograph offers a rare glimpse of "the upper end" of Timbuctoo. The street, running east to west toward Marysville, slopes sharply here. Add the heavy winter rains and it is easy to understand how one visitor could claim, "This street is impassable, not even jack-assable." Journalist and *Daily Appeal* editor Noah Brooks visited Timbuctoo in 1860. According to historian Richard Dillon, when Brooks stepped off the stagecoach, he saw the following scene: "Lounging in the doorway of the stage-stop hotel were a bummer, a miner on a 'bust,' a hungry-looking village lawyer, the hotel's portly landlord, and a 'sharp' boy. These rustics stared so intently at the coach's two female passengers that Brooks sarcastically termed them Timbuctoo's Committee of Public Safety." At the time of this photograph, 42-year-old Thomas H. Mayon of Kentucky had either turned over or was planning on turning over operations of the hotel to his 20-year-old son, William Henry. On the left side of the street, from left to right, are saloon keeper Jack ?, Henry C. Melbourne (over the X), and telegraph operator Charles ?. On the right side of the street are an unidentified man at street level, and storekeeper James Gordon on the boardwalk in front of the Empire Bakery. (Courtesy Library of Congress.)

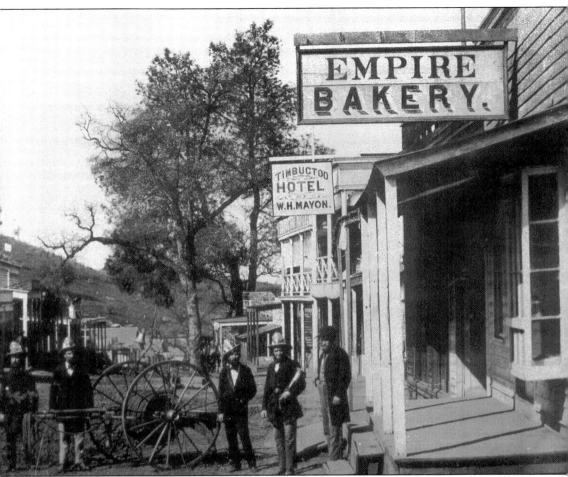

Timbuctoo's volunteer fire department posed for this photograph in 1859—perhaps on the same day as the image on page 26 was taken. The men are likely wearing their best uniforms, including helmets, for the occasion. The chief (perhaps Capt. J. Clark) stands second from the right, holding the trumpet. To his right might be Foreman Dennis Desmond. During the 1859 Fourth of July parade in Smartsville, Timbuctoo's hook-and-ladder company paraded with pikes; later that day, in the Timbuctoo Theater, the Rescue Hose Company held a firemen's ball attended by 85 couples and lasting until dawn. The Empire Bakery at this time was owned by James Pine, a 30-year-old native of England. His wife, Caroline, had been born in New York (the Empire State), likely giving Pine the name for his bakery. In the background, the Wells Fargo Building, with its brick facade and white-striped sign, can be seen on the right side of the street in front of the far oak. (Courtesy Stephen Anaya Collection.)

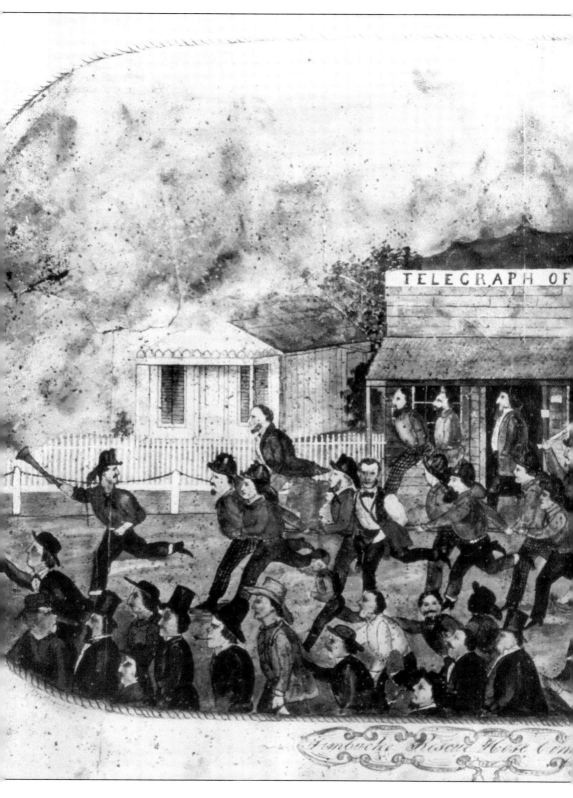

TELEGRAPH OF

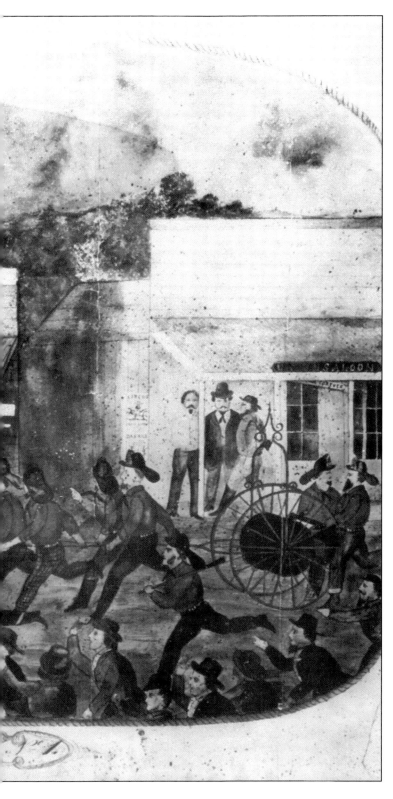

Pictured is artist George Barrington's 1860 fanciful image of Timbuctoo Rescue Hose Company No. 1. Out in front is the chief, directing the crew to the fire scene with his trumpet, while other volunteers pull the hose cart. One irony about a mining town such as Timbuctoo is that, although the region was crisscrossed with pipes and ditches carrying water for hydraulicking operations, fire was a constant danger. By August 10, 1860, Timbuctoo, according to the Marysville *Daily Appeal*, was "well supplied with water. . . . A six inch pipe runs through the village street with fire-plugs at convenient distances. From these water can be thrown over the top of the highest buildings in the place." Yet a fire in June 1878 destroyed a number of buildings, including the hotel built by Jacob Dufford, the post office, a saloon, and several houses. For a time in the mid- to late 1930s, according to H. T. Ellis, Barrington's color painting was "on exhibition in the Old Express Office and Pioneer Museum at Timbuctoo." The artwork is now among the holdings of the Mary Aaron Museum in Marysville. (Courtesy Yuba County Library.)

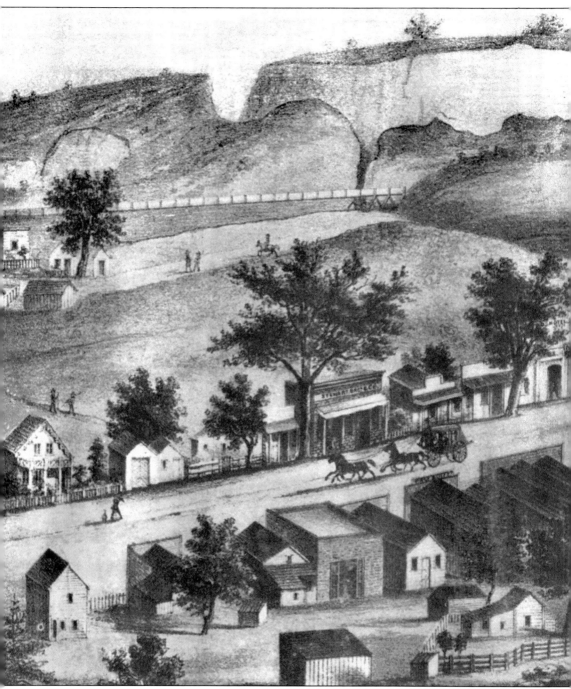

Timbuctoo is shown here in its heyday. By the time George Barrington produced this 1862 lithograph, the town was on its way to becoming the largest in eastern Yuba County, with a total population of 1,200 at its most prosperous. In addition to the Wells Fargo and Company office and Stewart Brothers Store, the town boasted a theater, church, blacksmith shop, drugstore, lumberyard, barbershop, livery stable, a second general store, two hotels, two carpenter shops, two tobacco and cigar stores, three clothing and dry goods stores, three bakeries, three shoe

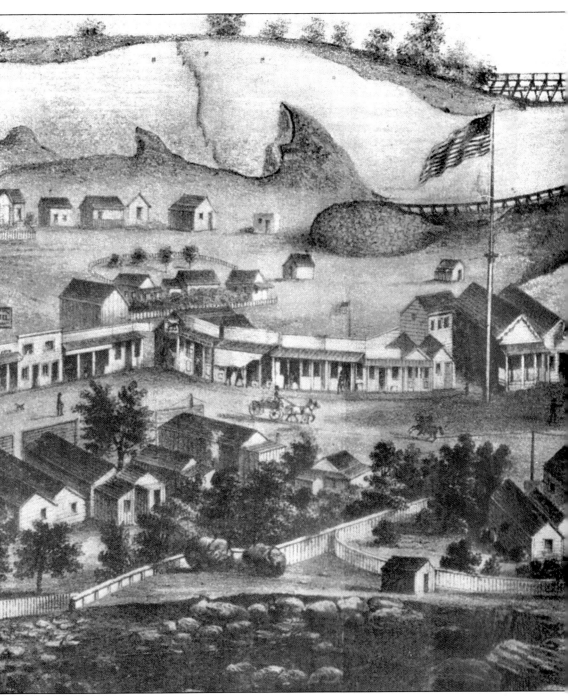

shops, six boardinghouses, and eight saloons. The Wells Fargo Building is depicted behind the horse and wagon team on the left side of the image, and the Timbuctoo Hotel stands just behind the two figures shaking hands. Note in the background the flumes and eroded hills from the hydraulicking operations. Compare and contrast this image with those on pages 40 and 46. (Courtesy Yuba County Library.)

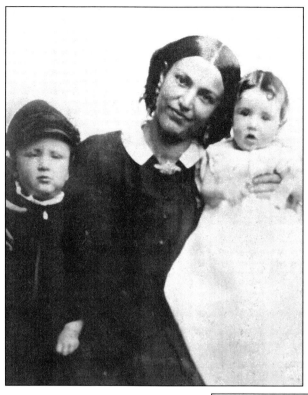

Fanny Brooks was photographed (left) in 1860 with her son George and daughter Eveline. In 1854, at the age of 17, Fanny left her home in Frankenstein (at that time in Prussia) and arrived in New York with her new husband (and cousin), Julius. In 1858, after crossing the country by wagon train, they ended up in Timbuctoo. Eveline Brooks was born in Timbuctoo on November 16, 1859. Though Fanny did her best to make a home, the family's three-room shack was so crudely built that wind through the walls sometimes blew out candles. Julius's mining claims did not pay off, and the family left in May 1860. They eventually settled in Salt Lake City. The photograph below shows Eveline on her engagement to fellow California native Samuel Auerbach, whom she married in 1879. (Both courtesy The Bancroft Library.)

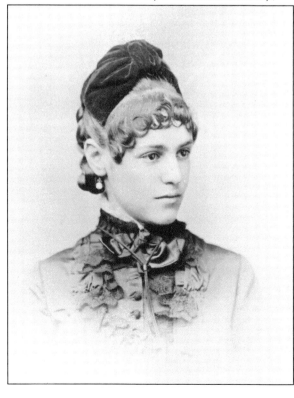

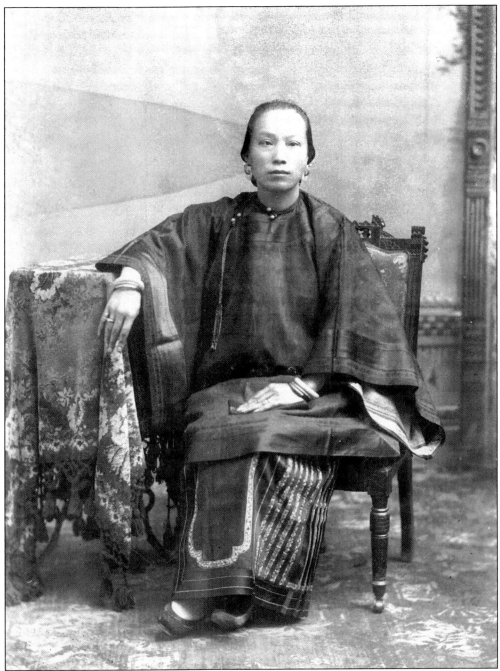

This photograph, taken at Griffiths Elite Gallery in Marysville around 1884, is likely of Suey Ah You's wife, Tong You. She, along with her husband, was reportedly extremely influential in Timbuctoo's Chinese community. On Saturday, June 1, 1907, according to the Nevada County *Daily Union*, she hit Timbuctoo native Peter A. Hanley on the head with a pole when Hanley arrived at her house to continue a mining claim dispute with her husband. Hanley died about six hours later. The Sueys left Timbuctoo around 1915 and settled in Marysville, where Suey began another tong. (Courtesy Harriet Galligan.)

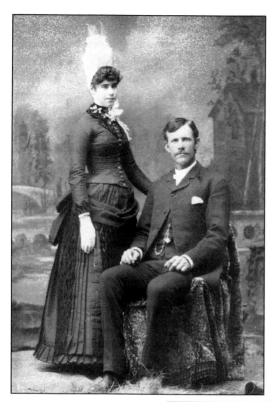

Hugh "Peter" Galligan moved with his family from the Midwest to eastern Yuba County when he was a boy. He later met Timbuctoo native Mary Elizabeth "Mame" McCarty, whose father, Andrew, had come from Ireland and settled in Roses Bar in 1853. Peter and Mary posed for this photograph at Clinch Studios in Grass Valley around the time of their wedding. They married on January 2, 1887, and the wedding celebration reportedly lasted a week. Peter and Mary ultimately settled in Marysville. (Courtesy Harriet Galligan.)

Eugene "E. D." Hapgood was born in Illinois in 1842 and by 1880 was working as a miner in Timbuctoo. Hapgood's bill for $10 for services performed on the Parks Bar Bridge went unpaid, so on April 27, 1887, he submitted this sworn deposition to the Yuba County Board of Supervisors. He received payment not long afterward. (Courtesy Searls Historical Library.)

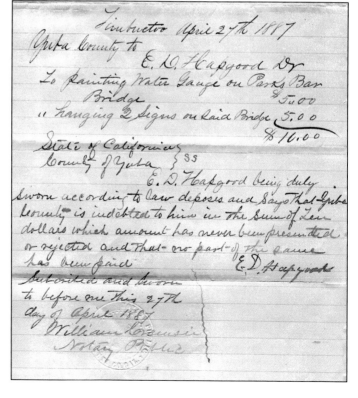

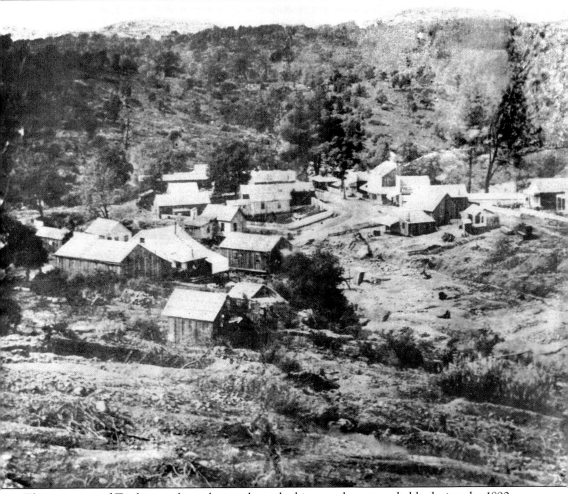

This is a view of Timbuctoo from the northeast looking southwest, probably during the 1890s. After its boom in the late 1850s and early 1860s, Timbuctoo's population steadily declined. The post office, established in 1858, was discontinued in 1883, and the village school had already been moved to Smartsville 10 years earlier. The boomtown, which by some estimates had once boasted a population of 2,000, by the late 1800s contained perhaps 200 people—most of them Chinese who continued to work the claims left behind by the whites. The Wells Fargo Building, at this time used exclusively as a general store, is just to the upper right of center just down from the oak tree in the road. (Courtesy Harriet Galligan.)

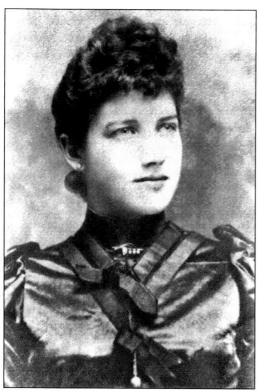

Bessie Peardon was born in 1873 in Ontario, Canada, and arrived with her parents in Smartsville by 1878. Here she met Timbuctoo native Phillip Smith, whom she married in 1892. The couple lived at the Smith family home in Timbuctoo. Bessie and Phillip had five children, the last in 1901. She died in 1905 of pneumonia and is buried at the Smartsville Masonic Cemetery. (Courtesy Kathleen Smith collection.)

A man poses with his horses and buggy in Timbuctoo on Sunday, October 10, 1909. The Wells Fargo Building is to the right, beginning at the end of the picket fence. (Courtesy Searls Historical Library.)

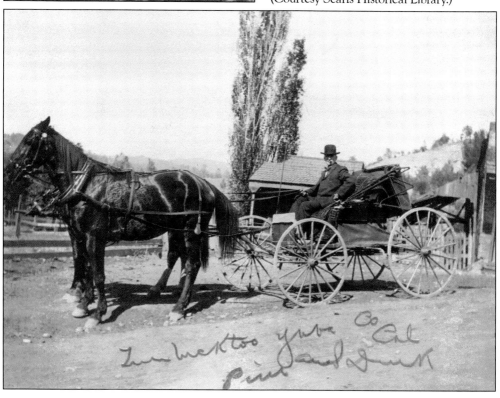

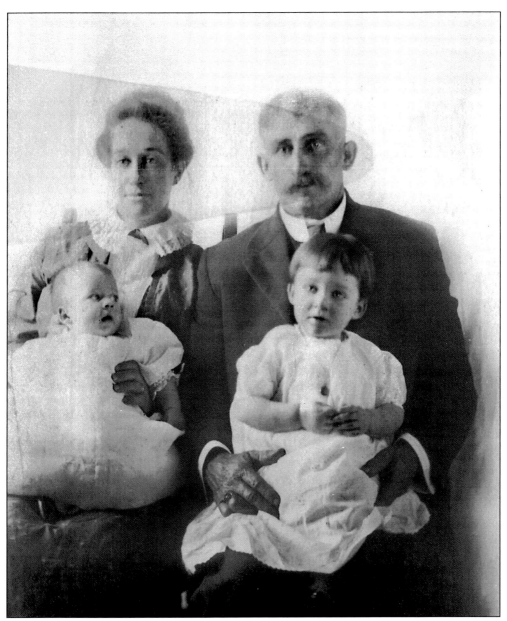

The McGovern family sat for this photograph in 1915. Clockwise from the upper left are Mary (Linehan) McGovern, Thomas "John" McGovern, Helen, and Jack. John met Mary around 1892, while he was living at Sand Hill and Mary was living in Smartsville. Her parents did not approve of the marriage, so for the next 20 years, John "prospected all over" until 1912, when the two finally married. In the meantime, Mary had spent three years in San Francisco earning her nursing degree. After their marriage, the McGoverns ultimately settled in Smartsville. Helen worked for 25 years as a proofreader for the *Appeal-Democrat* in Marysville. "We never had another portrait taken," Helen recalled. (Courtesy Helen McGovern.)

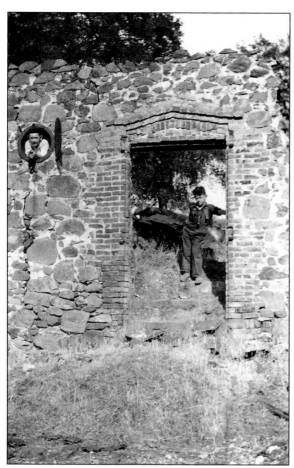

John Cosgrove was born in Ireland around 1830. By 1860, he was a merchant in Timbuctoo. He remained a merchant and storekeeper for at least the next 20 years. He died at James O'Brien's ranch on August 5, 1893. The photograph at left was taken on October 15, 1922. Bob McQuaid poses in the doorway while Billy Conlin peeks through the "porthole" in the wall. Below is a different view, taken about the same time, of the remains of Cosgrove's cellar wall and granary. (Left, courtesy Bill Conlin; below, California Historical Society.)

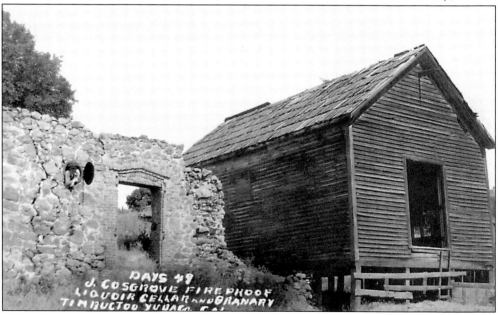

This photograph of a barn in Timbuctoo was taken in the early 1900s. Perhaps this is the same barn built in 1878 using materials from the town's dismantled church. (Courtesy California Historical Society.)

A lone cow looks north toward the mining-scarred hills behind Timbuctoo. This photograph was taken in February 2007 from approximately the place where the Empire Bakery once stood. (Photograph by Lane Parker.)

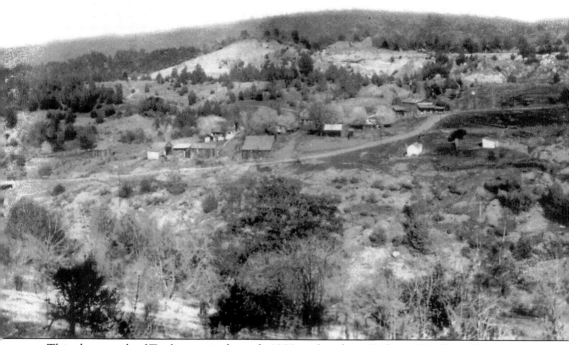

This photograph of Timbuctoo in the early 1900s, taken from Highway 20, offers a fine yet stark view of the town's main street, Timbuctoo Road. The newly rebuilt Timbuctoo Bridge can be seen at the far left, while the Wells Fargo Building sits atop the rise in the road off to the right. Compare and contrast this image with those on pages 30 and 46. Compared with the 1862 lithograph, the change in the look of the town is dramatic. (Courtesy Tammy L. Hopkins.)

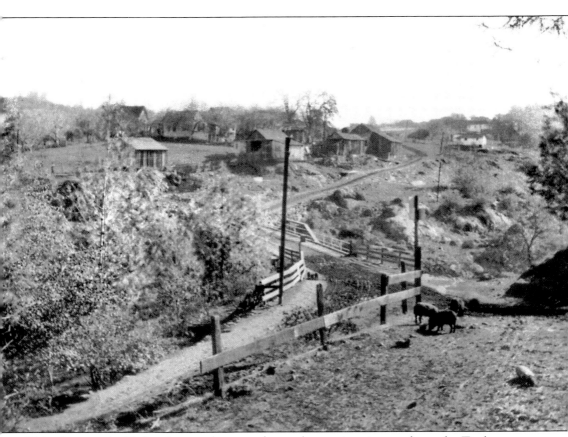

This photograph, likely taken on the same day as the previous image, shows the Timbuctoo Bridge from the west looking east. On May 5, 1909, the Marysville *Daily Appeal* announced, "The bridge material for the Timbuctoo Bridge arrived at the Marysville Southern Pacific depot yesterday and will be hauled to the site of the new bridge at once and work begun as soon as the contractors can get the material and men on the ground." Over the next several years, however, heavy rains continued to damage the bridge, leading to emergency repairs. By mid-February 1915, work was done "under emergency measures to restore traffic over the structure, as the abutment was considerably damaged by water as a result of the recent heavy rains," according to a different issue of the *Daily Appeal.* In 1997, further flooding crippled the bridge, which currently remains closed to vehicle traffic. (For reference, the Wells Fargo Building is located out of sight up around the far bend in the road.) (Courtesy Tammy L. Hopkins.)

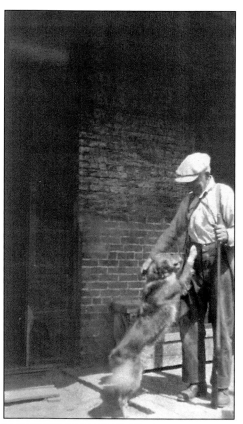

A man, perhaps Sam Gunning Jr., pets a dog in front of the Wells Fargo Office sometime around the 1930s. (Courtesy California Historical Society.)

This photograph of the town well at Timbuctoo was probably taken in the 1930s. According to Harriet Galligan, who on numerous occasions visited her grandparents at Timbuctoo, "That well had the best water." The remains of the well were visible into the early 1980s. (Lane Parker collection.)

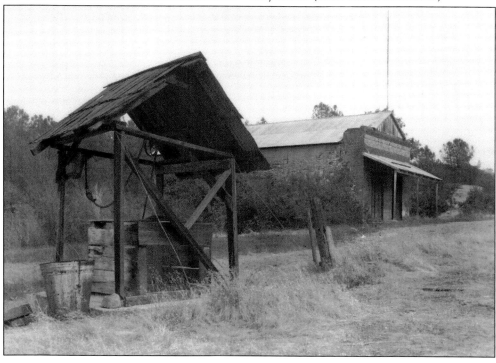

This photograph of Timbuctoo resident William "Wild Bill" Gruber was taken in April 1976. Born in Illinois on August 3, 1900, Gruber worked in Los Angeles for a while as a welder and reportedly was a some-time stand-in for Tom Mix before moving to Northern California. In Timbuctoo, he was at one point the semiofficial caretaker of the Wells Fargo Building. Gruber died on April 25, 1991. He is buried at the Smartsville Catholic Cemetery. (Courtesy SAMCC.)

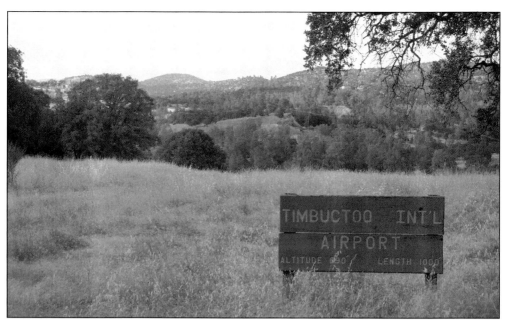

Located at Bonanza Ranch to the south across the Big Ravine from Timbuctoo, the "Timbuctoo International Airport" was, until the early 1990s, the private airstrip of landowner and small plane pilot Pete Huckins, who apparently did not need a graded or even horizontal runway. This photograph was taken in 2007. (Photograph by Lane Parker.)

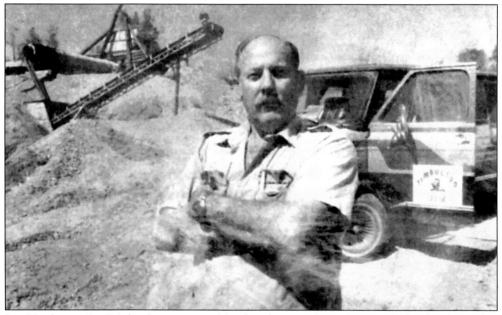

Jim "Timbuctoo Jim" Ashenbrenner posed for this photograph in 1986, just before he planned to begin surface-mining operations in Timbuctoo. Ashenbrenner purchased the town site for $750,000 in 1978. Often he lived in a mobile home near the Wells Fargo Building while he developed his plans to re-create Timbuctoo by rebuilding the Wells Fargo Office and the Timbuctoo Hotel and even opening up the site for further small-scale gold mining. "Someday before you die," Ashenbrenner said, "there will be a town here." (Courtesy Searls Historical Library.)

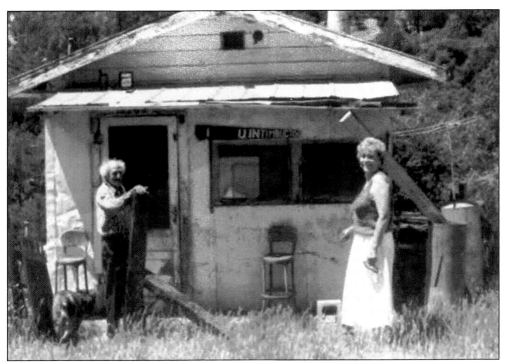

While living in Sacramento, Laverne Denyer and her friend Nellie Thompson (pictured here at right) visited Timbuctoo in the late 1980s and met this man, one of Timbuctoo's few remaining residents. In 1970, only Lavina Ray, Bill Gruber, and Dave Chambers called Timbuctoo home—and even then the three rarely saw each other. Ray referred to Gruber as "Old Whiskers next door," unaware that Bill had been beardless for several months. This man (possibly Gruber) invited Laverne and Nellie into his house for cookies and talked with them for about three hours. (Photograph by Laverne E. Denyer.)

A closer look at the rusty saw blade on the house reveals the message, "I . . . U IN TIMBUCTOO." The saw reportedly was a relic from the old museum in Timbuctoo. (Photograph by Laverne E. Denyer.)

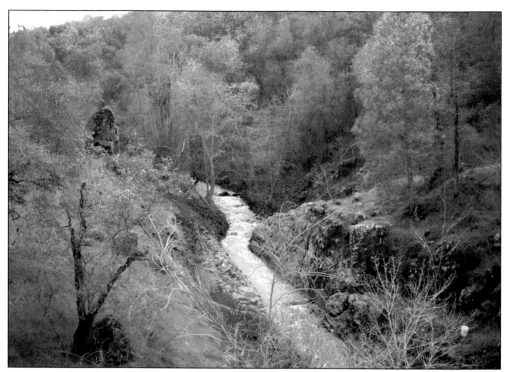

This view of Sanford Creek was taken looking east up Timbuctoo Ravine from Timbuctoo Bridge in February 2007. Monroe Sanford arrived in California in 1849 and mined along the Yuba River before moving on to establish a ranch outside of Sacramento. In the early 1850s, his brothers, Levi and Nathan, immigrated to California and operated a ranch one mile south of Smartsville. Another brother, Benjamin, according to Thompson and West, "Went to work . . . on the dairy farm, and peddled the milk on a pack-horse to the miners." (Photograph by Lane Parker.)

This photograph of Timbuctoo Road was taken in February 2007 from Highway 20. Compare and contrast this image with those on pages 30 and 40. (Photograph by Lane Parker.)

# *Three*

# TIMBUCTOO
## RELICS OF PIONEER DAYS

The last surviving building of Gold Rush Timbuctoo was popularly known both as the Wells Fargo Office and as the Stewart Brothers Store. Given the building's purpose, and therefore its construction of native fieldstone and iron doors and shutters, it's not surprising that it outlasted the rest of Timbuctoo's buildings. According to historian Richard H. Dillon, author Carl Glasscock "found Timbuctoo's surviving structure to be an excellent example of Gold Rush vernacular architecture."

In the early days of the Gold Rush, robbery was rare and miners weren't overly concerned with others stealing their pokes. Once all of the good claims had been taken, however, the atmosphere became more desperate and many men left prospecting and became bandits. Henry Wells had learned from talking to miners that what they wanted most after getting their gold out of the ground was to get it into a safe place as soon as possible.

In the smaller camps such as Timbuctoo, Wells Fargo stationed agents at offices open seven days a week. Safes, steel doors, cast-iron shutters, and other building materials were shipped from the East Coast.

At Timbuctoo, Wells Fargo operated out of the building only briefly and on two separate occasions. Abe Stewart represented the company from October 1855 until April 1856. In May 1856, due to a territorial agreement, expressman Samuel Langton owned the enterprise in Timbuctoo. Upon Langton's death in 1864, P. A. Lamping's Express bought the concern. In 1866, Wells Fargo bought out Lamping and let John MacAllis and James Gordon, Langton's former agents, handle daily operations until March 22, 1869, when MacAllis took over sole operation. In 1871, S. C. Wessells served as Wells Fargo's final agent. Later, before his move to Marysville, Suey Ah You operated his Suey Sing store out of the building and formed the Suey Sing Tong there.

In the following decades, the building was home to other general stores, a museum, and finally only memories and dust. Two efforts at historic preservation, one by the Native Daughters of the Golden West and the other by local residents and schoolchildren, met with only temporary success. In the end, the building was plagued by its own glorious past: Vandals and treasure hunters repeatedly broke through the stone walls in search of gold rumored to be hidden inside the building.

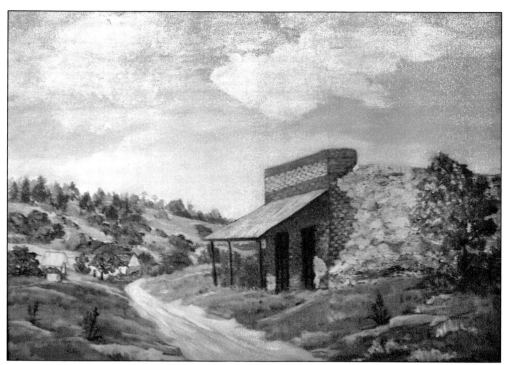

Marysville resident Marilyn Herboth painted this image of the Wells Fargo Building for an art class she was taking. Following the instructions for the assignment, she chose a subject she felt no one else had attempted. (Courtesy Harriet Galligan.)

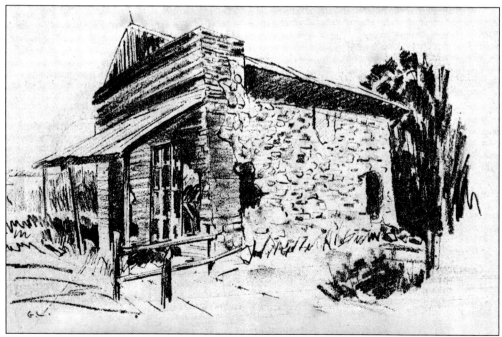

The caption on this 1974 sketch reads, "Back to the elements because 'it would cost a fortune' to restore." Compare this with the photograph on page 60. (Courtesy SAMCC.)

This is a detail of George Barrington's 1862 lithograph (shown in its entirety on pages 30 and 31) from Thompson and West. The lettering on the white striping of the store's brick facade reads "Stewart Bros. & Co." In its heyday, the general store housed not only a Wells Fargo Express Office but also a post office, saloon, and gold dust exchange. In one early legend, bandit and "Po8" Black Bart reportedly robbed the office at Timbuctoo and fled to Penn Valley—where he was captured but without the gold in his possession. (Courtesy Yuba County Library.)

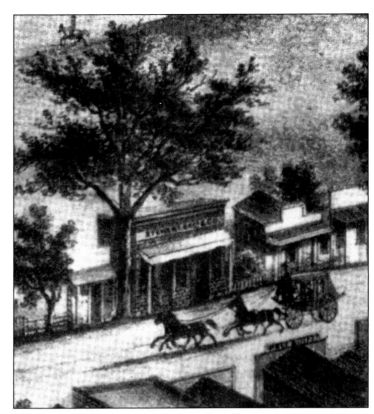

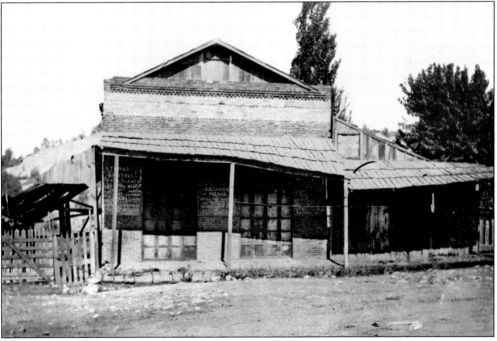

This photograph was taken on Sunday, October 10, 1909. Since the gold mining days, structures have been added to either side. The willow apparently is gone. (Courtesy Searls Historical Library.)

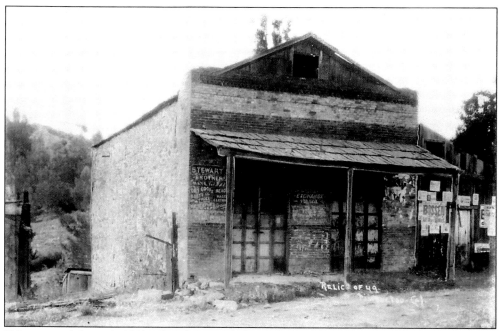

Taken around the early 1910s, this photograph shows the building's continued deterioration. The lean-to on the left is gone, and the structure on the right is covered with campaign fliers and other bills. (Courtesy SAMCC.)

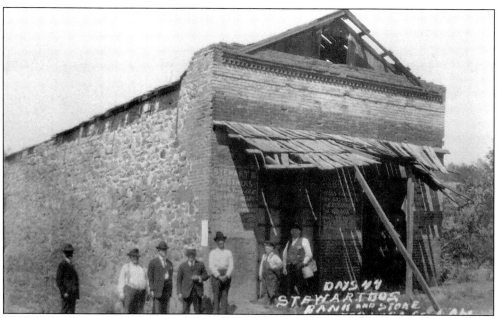

This photograph was taken around 1915, when the overhang and roof were nearly gone. (Courtesy California Historical Society.)

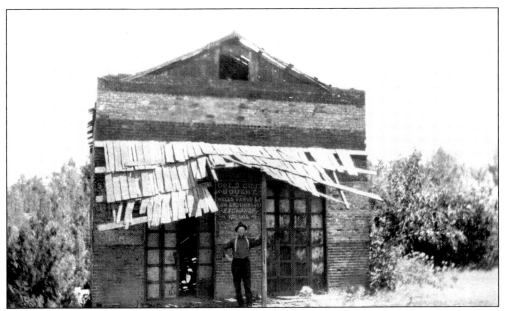

Andrew Hedemark poses beneath the collapsing wood-shingled awning in this photograph, taken around 1915. (Courtesy Searls Historical Library.)

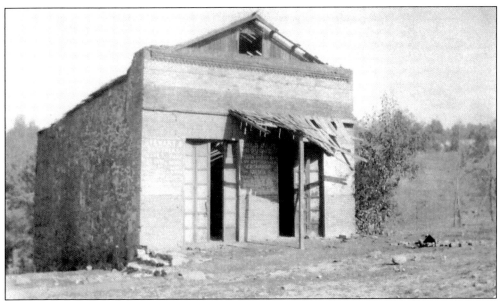

In 1921, a visitor observed, "The old bank is still standing, being of brick, with iron doors but no roof. The same sign of olden days is still on this building." (Courtesy California Historical Society.)

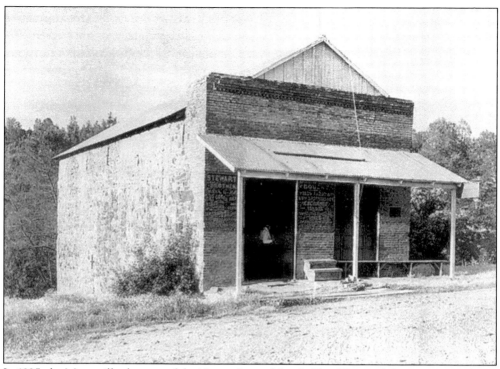

In 1925, the Marysville chapters of the Native Sons of the Golden West and the Native Daughters of the Golden West completed a partial restoration of the building, replacing the deteriorated roof and overhang with corrugated iron. The commemorate plaque, which can be seen at right in the image above and at left below, is visible on the brick facade. The sign at below right, placed not far from the Wells Fargo Building, was dedicated by Marysville Parlor No. 6 (Native Sons of the Golden West) and Marysville Parlor No. 162 (Native Daughters of the Golden West). According to a report in March 1930, "Speakers included Grand President Esther R. Sullivan, Past Grand President Allison F. Watt and Past Grand President Dr. Louise C. Heilbron of the Native Daughters; Past Grand President Fred H. Greely and Superior Judge F. P. McDaniel of the Native Sons. California songs were rendered by the glee club of Marysville Parlor N.D.G.W." The photograph above was probably taken in the 1940s. (Above, courtesy Library of Congress; two below, Yuba County Library.)

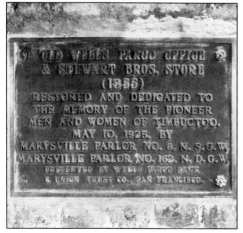

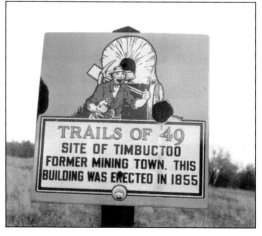

According to a 1932 travel publication, "This long tom reposes in the Wells-Fargo building at Timbuctoo, which has been made into a museum." The museum featured, among other artifacts, miners' rifles, whiskey bottles, and old photographs and sketches of the town. (Courtesy Searls Historical Library.)

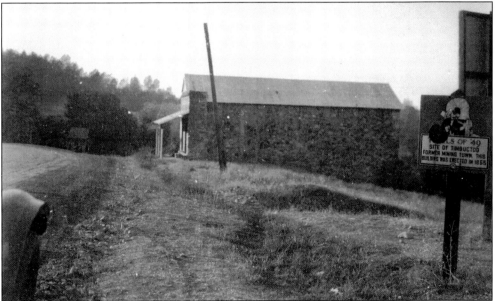

This photo postcard is one of two dated April 20, 1934. The visitor noted: "Timbuckto, side view of building built 1855 in famous Mining Camp. Now a Museum containing many relics . . . filled to capacity with relics of pioneer days—wheels, shovels, etc. etc. . . . Always open to visitors without a guard and without loss from souviner grabbers. Very remarkable." (Courtesy Society of California Pioneers, San Francisco.)

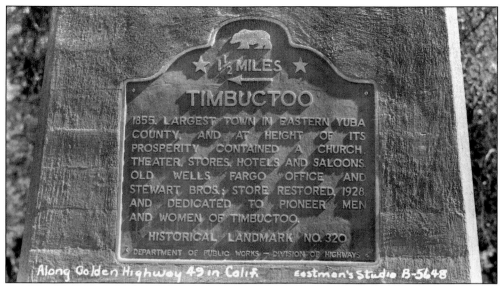

On July 12, 1939, California designated Timbuctoo, or at least the Wells Fargo Building and Stewart Brothers Store, State Historic Landmark No. 320. (Mission Dolores, the oldest surviving building in San Francisco, is Landmark No. 327.) This 1947 photograph shows the marker erected to the east of Timbuctoo along Highway 20. Note that California's Department of Public Works believed the Wells Fargo Building was restored in 1928 rather than 1925. This marker no longer exists. A 5-mile marker across the Parks Bar Bridge to the west still stands but with the same erroneous date. (Courtesy Yuba County Library.)

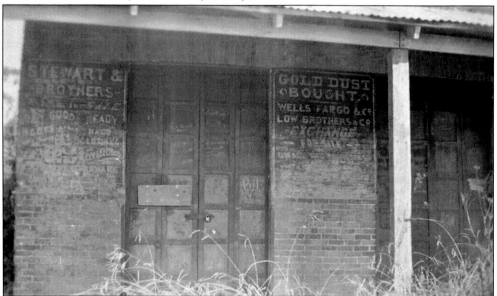

This image, taken around the 1940s, features the east door of the building with the old 1860s signs on either side. The sign on the left front wall reads, "Stewart & Brothers have for Sale Dry Goods, Boots and Shoes, Ready Made Clothing, Groceries & Provisions, Crockery, Hardware & Liquors." The sign on the center front wall reads, "Gold Dust Bought. Wells, Fargo & Co., Low Brothers & Co., Exchange for Sale on all the Principal Cities of the Atlantic States and Europe." (Courtesy Society of California Pioneers, San Francisco.)

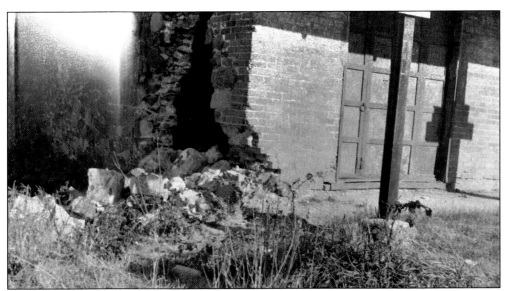

"When I made my first pilgrimage there," remarked historian Richard Dillon about his early-1950s visit, "the Stewart Store was still in pretty good shape." In April 1957, Sam Gunning Jr. took this photograph of the (initially) small hole in the west wall. Gunning and Smartsville resident Asa Fippin worked for a time at trying to restore the building. (Courtesy Society of California Pioneers, San Francisco.)

This is the Ghost Town Restoration Festival program for July 12, 1964. (The reverse side of this program appears on page 120.) As early as 1963, John Mayer, a fifth-grade teacher at Lone Tree School on Beale Air Force Base, was trying to save the building. He and his class of 10-year-olds spent many Saturdays removing weeds and salvaging fallen bricks. (Courtesy Yuba County Library.)

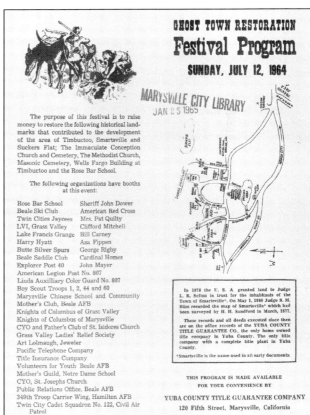

GHOST TOWN RESTORATION
Festival Program
SUNDAY, JULY 12, 1964

MARYSVILLE CITY LIBRARY
JAN 25 1965

The purpose of this festival is to raise money to restore the following historical landmarks that contributed to the development of the area of Timbuctoo, Smartsville and Suckers Flat; The Immaculate Conception Church and Cemetery, The Methodist Church, Masonic Cemetery, Wells Fargo Building at Timbuctoo and the Rose Bar School.

The following organizations have booths at this event:

Rose Bar School / Sheriff John Dower
Beale Ski Club / American Red Cross
Twin Cities Jaycees / Mrs. Pat Quilty
LVI, Grass Valley / Clifford Mitchell
Lake Francis Grange / Bill Carney
Harry Hyatt / Asa Fippen
Butte Silver Spurs / George Rigby
Beale Saddle Club / Cardinal Homes
Explorer Post 40 / John Mayer
American Legion Post No. 807
Linda Auxilliary Color Guard No. 807
Boy Scout Troops 1, 2, 44 and 60
Marysville Chinese School and Community
Mother's Club, Beale AFB
Knights of Columbus of Grass Valley
Knights of Columbus of Marysville
CYO and Father's Club of St. Isidores Church
Grass Valley Ladies' Relief Society
Art Lolmaugh, Jeweler
Pacific Telephone Company
Title Insurance Company
Volunteers for Youth Beale AFB
Mother's Guild, Notre Dame School
CYO, St. Josephs Church
Public Relations Office, Beale AFB
349th Troop Carrier Wing, Hamilton AFB
Twin City Cadet Squadron No. 122, Civil Air Patrol

In 1878 the U. S. A. granted land to Judge L. R. Selton in trust for the inhabitants of the Town of Smartsville*. On May 1, 1880 Judge S. M. Bliss recorded the map of Smartsville* which had been surveyed by H. H. Sandford in March, 1877.

These records and all deeds executed since then are on the office records of the YUBA COUNTY TITLE GUARANTEE CO., the only home owned title company in Yuba County. The only title company with a complete title plant in Yuba County.

*Smartsville is the name used in all early documents.

THIS PROGRAM IS MADE AVAILABLE
FOR YOUR CONVENIENCE BY

YUBA COUNTY TITLE GUARANTEE COMPANY
120 Fifth Street, Marysville, California

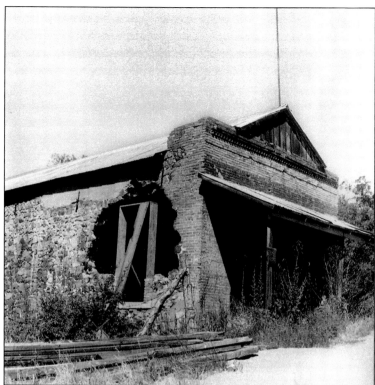

This 1964 photograph shows the expanding hole in the west wall and the attempt to shore up the building. Remi Nadeau commented in 1965, "Another flourishing town of the '50s was Timbuctoo, which is now marked only by the shell of the Wells Fargo Office." (Courtesy SAMCC.)

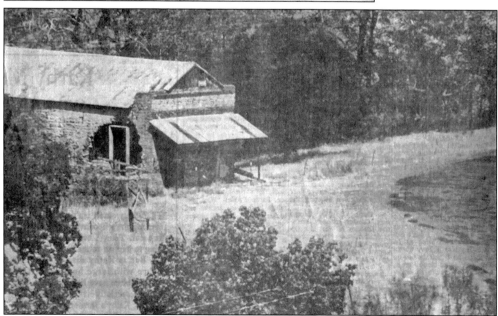

This 1967 photograph shows only part of the damage done to the Wells Fargo Building in the years since its restoration by the Native Daughters of the Golden West in 1925. (The entire rear wall of the building is gone.) Tourists and other passersby have covered the fireproof iron doors with their names and hometowns, and treasure hunters have broken through the walls, following rumors of gold still hidden somewhere within. (Courtesy Yuba County Library/*Appeal-Democrat*.)

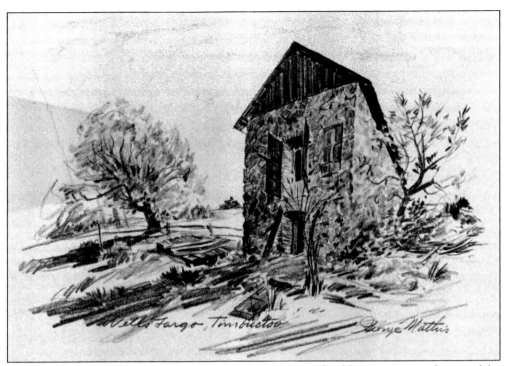

This sketch, published in a 1940s-era Nevada County tourist booklet, gives a rare glimpse of the back of the Wells Fargo Building. (Courtesy Society of California Pioneers, San Francisco.)

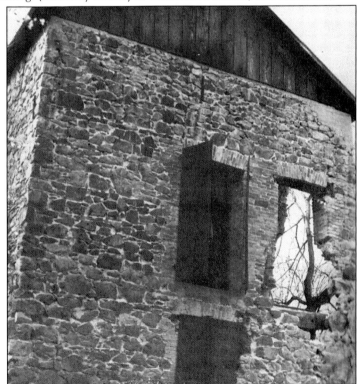

In this image of the back of the building in the late 1960s, note that some of the iron shutters remain. (Courtesy Florin Lambert.)

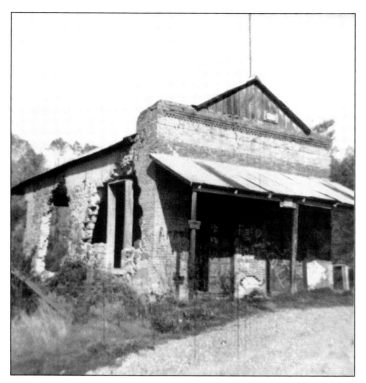

The west wall is shown in 1970. "When . . . I first stopped there, in the nineteen-seventies," writes John McFee in *Assembling California*, "a roofless masonry building . . . was all there was of Timbuctoo." (Courtesy Searls Historical Library.)

The hole in the west wall, from inside the building, was photographed in 1970. John Mayer, the teacher at Lone Tree School who in 1963 had organized a class of fifth graders in a restoration effort, said of the building in 1971, "It's so bad I don't bother to go out there anymore." (Courtesy Searls Historical Library.)

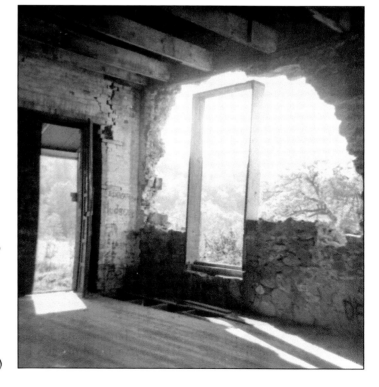

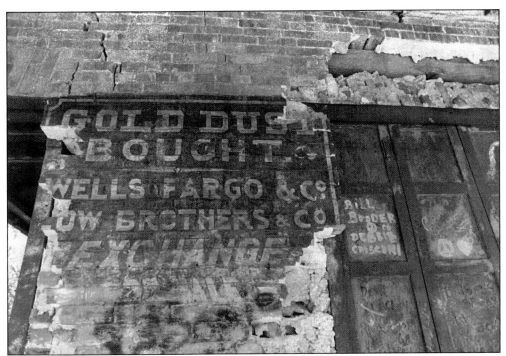

As seen in this 1974 photograph, much of the old sign is still visible, even amid the graffiti. In the 1970s, according to John McFee, the building's signs were "barely legible in fading paint." (Courtesy SAMCC.)

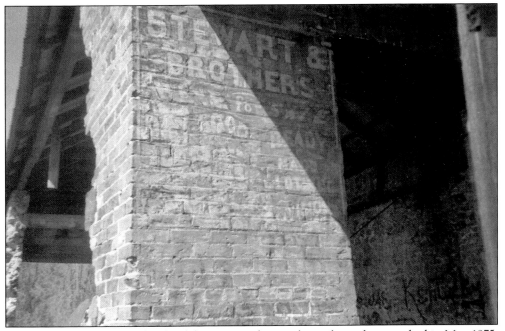

The painted sign to the left side of the western door is shown here photographed in May 1975. Henry C. Melbourne printed the sign in 1858 for Abe and Sam Stewart. (Courtesy Yuba County Library/*Appeal-Democrat*.)

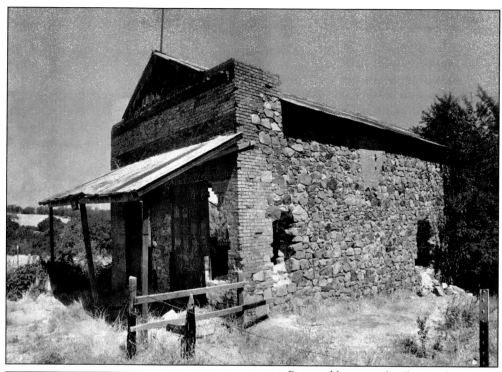

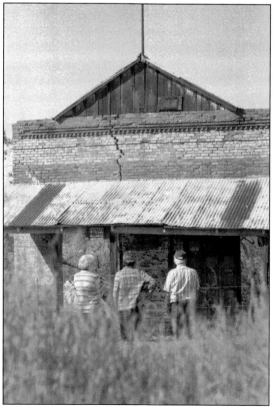

Pictured here are the "battered remains of the Wells Fargo Building" in 1974. Compare this with the sketch on page 48. In mid-April of 1974, Sam Gunning reported the building's iron doors missing. Thieves used a cutting torch to remove the doors, a Yuba County Sheriff's Office investigation found. (Courtesy SAMCC.)

Visitors to Timbuctoo study the building in April 1976. In Smartsville, residents were providing tourists with directions to Timbuctoo, along with a warning to watch out for "crazy Bill Gruber; he makes a lot of noise, but he's not that bad." (Courtesy SAMCC.)

This photograph, taken in April 1976, shows the eastern door from inside the building. In early May 1976, Virginia Creely wrote to a Yuba County official, "I was pleased to receive your letter regarding plans, if almost too late, to salvage what remains of this Wells Fargo Building, which when my parents inherited the land, was in sound condition." (Courtesy SAMCC.)

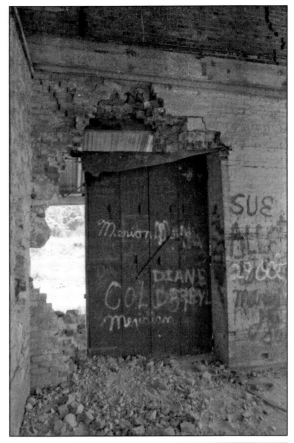

This is a view of the building from the west looking northeast in April 1976. (Courtesy SAMCC.)

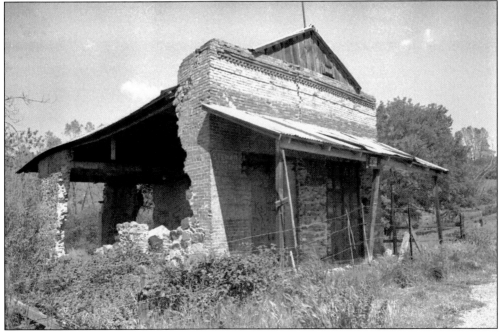

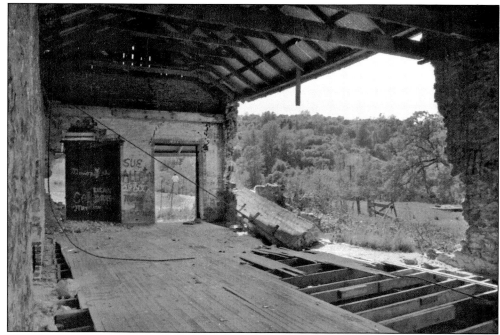

This photograph from April 1976 was taken from the back of the building looking toward the front. Through the hole in the western wall trees and shrubs lining Timbuctoo Ravine to the south can be seen. (Courtesy SAMCC.)

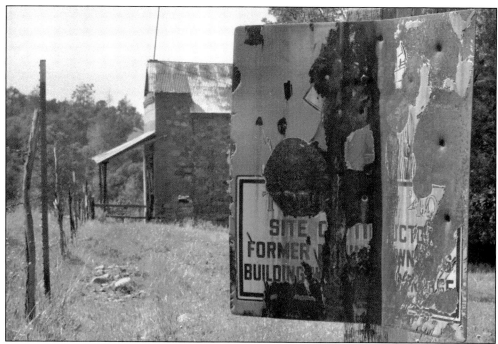

Another photograph from April 1976 shows in the foreground the "Trails of '49" sign, dedicated in 1930. Compare this with the image on page 52. (Courtesy SAMCC.)

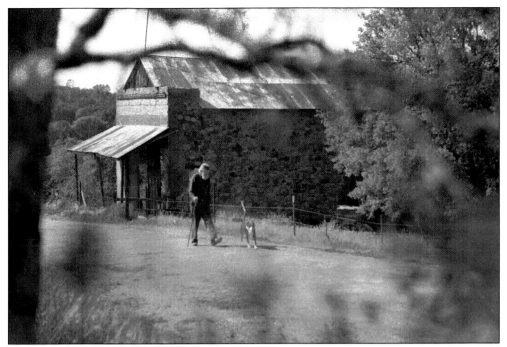

The building's semiofficial caretaker in April 1976 was William "Wild Bill" Gruber, who reportedly ran up yelling and shaking a stick at thieves and vandals. Here he is with his dog Meeny. Other of the building's watchmen over the years included Thomas Smith, who died in 1935, and Matt McCarty, dubbed "The Mayor of Timbuctoo" because of his role as the building's caretaker. (Courtesy SAMCC.)

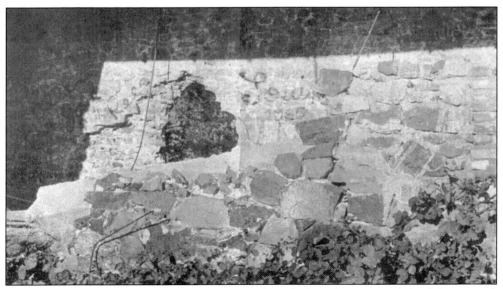

This photograph, taken in July 1978, provides a closer look at the stonework (and destruction) in the building's east wall. (Courtesy Yuba County Library/*Appeal-Democrat*.)

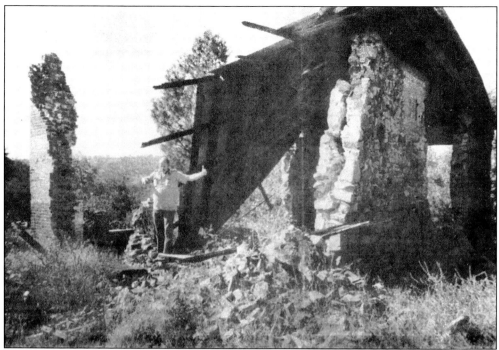

"Timbuctoo Jim" Ashenbrenner displays the relic in mid-August 1986. In addition to owning the land at Timbuctoo, 49-year-old Ashenbrenner was operating a SCUBA diving equipment business in Los Angeles and was a partner in a gold dredger manufacturing operation and a sunken Japanese submarine off of Samoa. (Courtesy *Nevada County Daily Union*/Searls Historical Library.)

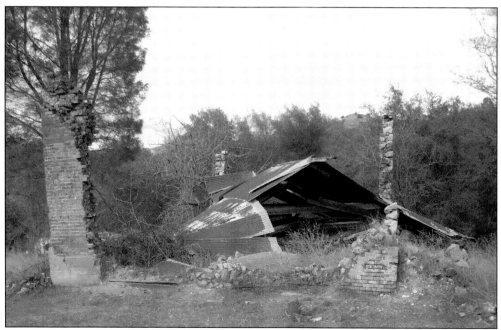

This photograph was taken in February 2007. The building's remains are currently located on private property and protected by a high chain-link fence. (Photograph by Lane Parker.)

# *Four*

# MINING SMARTSVILLE AND TIMBUCTOO

On Monday, January 24, 1848, James Marshall discovered gold in the American River at Sutter's Mill. A little over four months later, on Friday, June 2, Jonas Spect found the precious metal along the Yuba, at a bar that later would be known as Roses Bar. Spect made his pile and left the Yuba. Those who arrived later discovered that plenty remained for them. In the beginning, miners used pans, picks, and shovels. Later they formed groups and worked their claims with long toms and sluices. Soon mining companies formed, and the lone miner usually either joined these bigger operations or quit the gold fields.

Bigger operations usually meant hydraulic mining, which by its very nature required companies with outside investors and large, complex infrastructures. Entire hillsides disintegrated under the steady stream of water from the "monitors." While the solitary miner had often worked claims inside ravines, hydraulicking created its own ravines, canyons, and wastelands.

In the early 1880s, a former shareholder in mining operations named Edwards Woodruff put his name to what would become a landmark case in environmental law. On January 7, 1884, Judge Lorenzo Sawyer decided in the plaintiff's favor in *Woodruff v. North Bloomfield Gravel Mining Company.*

Contrary to popular belief, the Sawyer decision did not end hydraulic mining operations. For many years, companies carried on clandestine or at least scaled-back hydraulicking operations. On May 26, 1909, the Marysville *Appeal* ran an article about signs posted in nearby Placer County warning trespassers (that is, Anti-Debris Association observers), "Retrace your steps as speedily as possible or you will be roughly handled and subject to arrest. We are not hiring any help and do not want any sightseers. Get out and stay out." Copies, noted the *Appeal*, "Have been sent to each member of the anti-debris association."

Still, mining continued on much smaller scales. Once many companies abandoned their "worked-out" claims, Chinese miners often took over and literally scraped out a living. Reportedly Chinese miners paid $200 for one claim in Timbuctoo, from which they yielded $30,000.

This is the Mark Anthony [*sic*] cyanide plant at Timbuctoo. After leaching out gold and silver using a sodium cyanide solution, miners added zinc, which separated the mixture into zinc, gold, and silver. Adding sulphuric acid then removed the zinc, which left a silver and gold amalgam ready for final processing. Extracting gold using the cyanide process was dangerous to miners and especially damaging to the environment. (Courtesy Mary Clark.)

This shows the surface workings at the Mark Anthony [*sic*] Mine at Timbuctoo. At its height, the mine boasted a five-stamp, water-powered ore mill. This collection of buildings is likely the same one seen on the hill overlooking the cyanide plant in the above image. History buff Samuel O. Gunning owned (and named) the mine. (Courtesy Mary Clark.)

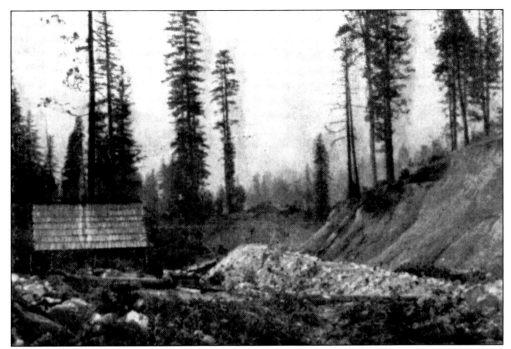

This detail from a 1930s promotional pamphlet, "Homes and Happiness in Yuba County California," offers a view of the old Timbuctoo Mine (spelled "Timbucktoo" in the literature). (Courtesy Society of California Pioneers, San Francisco.)

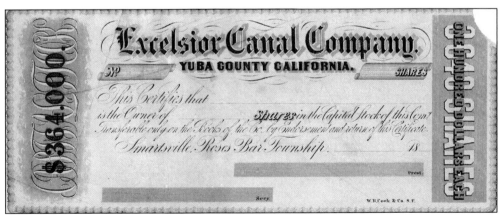

By 1866, a series of sales and consolidations of ditches and water rights ended with the Excelsior Canal Company controlling all of the approximately 150 miles of ditches in the Smartsville and Timbuctoo area. Headquartered in Smartsville, the Excelsior Company was first organized by a group of miners at the Branch Saloon in Roses Bar in January 1855. (Courtesy Society of California Pioneers, San Francisco.)

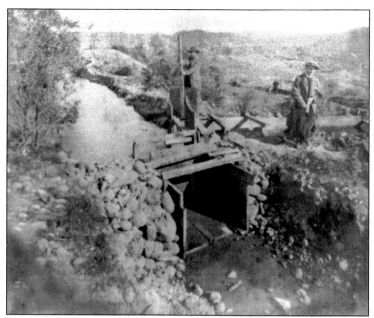

Miners had begun building ditches as early as 1850. By the time hydraulicking was in full swing, hundreds of miles of ditches ran from the Yuba River to the mines. In 1858, one ditch, the Tri-Union, began at Deer Creek and ran 60 miles to Sucker Flat, Timbuctoo, and Ousley's Bar. The 1866 image above was taken of a ditch in Yuba County. At the gate, operators could control the flow of water from the ditch to the diggings. According to Augustus J. Bowie in *A Practical Treatise on Hydraulic Mining in California*, the pressure box, located at the end of the ditch in "a commanding position" above the claim, was made of planks and held together with timber, and "sufficiently large and deep to keep the head of the pipe, which enters it, under water with a steady pressure." The image below, taken in 1866, shows a pressure box operating around Smartsville and Timbuctoo. (Both courtesy Library of Congress.)

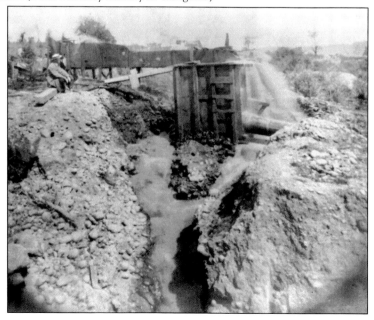

Pictured here are a tank and pipe used in the operations around Smartsville and Timbuctoo in 1866. By this time, the two-inch canvas duck of the early years had given way to pipes made of 18-inch boiler iron. (Courtesy Library of Congress.)

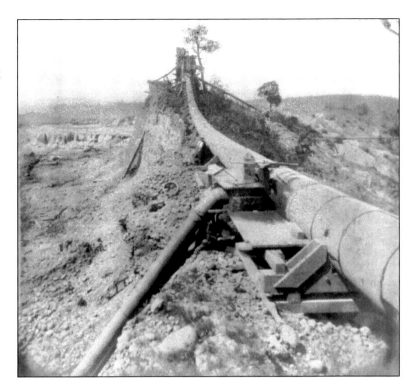

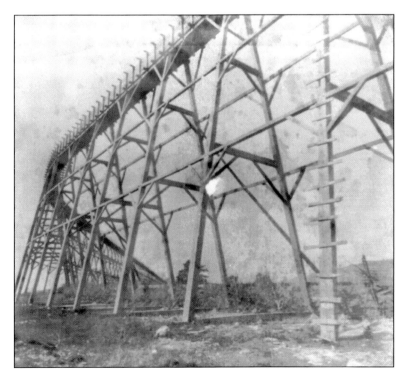

This flume near Smartsville was an elaborate but effective way to divert water during mining operations. Flumes varied from 40 to over 100 feet long and were usually 2 feet wide and 1 foot deep. The higher the flume, the more expensive it was to build and maintain. (Courtesy Library of Congress.)

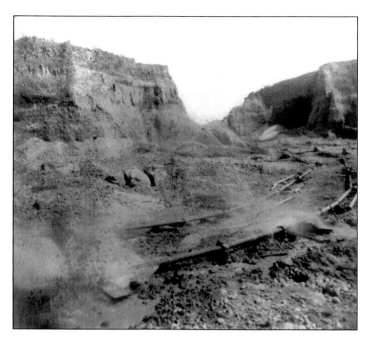

This 1866 photograph shows pipes carrying water at the Timbuctoo diggings. For water traveling in iron pipes, according to *A Practical Treatise on Hydraulic Mining in California*, "The fall is the only force used in throwing the stream. A fall of 200 feet will throw a stream with terrific force a distance of 175 feet." Also seen are water sprays from seams in the pipes on the way to hoses and 16-foot iron nozzles. (Courtesy Library of Congress.)

At the Timbuctoo diggings in 1866, according to the image's description in the Lawrence and Houseworth Collection, miners are "washing down the bank into the sluice." The nozzles (called "monitors" after their most famous manufacturer) are shooting water into the hillside at 120 pounds of pressure per square inch—150 feet per second, or over 100 miles per hour. (Courtesy Library of Congress.)

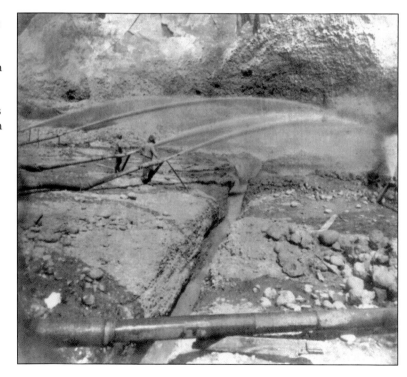

Pictured is the Kentucky Claim at Timbuctoo. Not long after arriving in California in 1850, a 30-year-old Lorenzo Sawyer wrote, "Insensible indeed must that man be who can stand upon this place and gaze upon the sublimities of nature around him without forgetting self in admiration of this display of Almighty power." (Courtesy Library of Congress.)

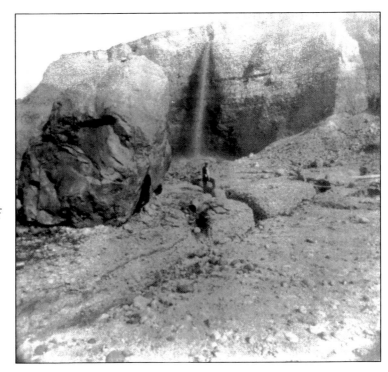

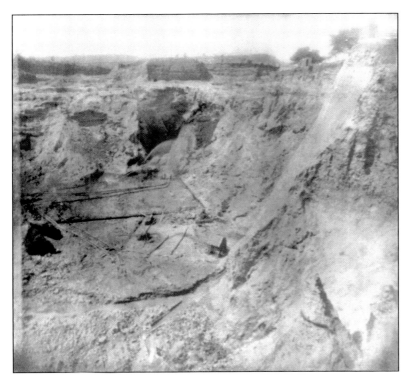

The lower "lead" of the Blue Gravel Mine near Smartsville is shown in 1866. This operation was reportedly the richest in the state, yielding nearly $600,000 from March 1864 to August 1866. "The hills washed away are sometimes over two hundred feet high," according to Thompson and West in 1879. (Courtesy Library of Congress.)

This wagon team is hauling sluice blocks to nearby operations at Smartsville in 1866. The blocks, 6 to 10 inches thick and 20 inches wide, were used to line the bottoms of the sluice tunnels. Sluice tunnels were usually made 2 to 3 feet wider than the inside width of the sluice, and 7.5 to 8 feet high. The tunnels ran from 500 to 4,000 feet long, and cost $12 to $50 a foot to construct. (Courtesy Library of Congress.)

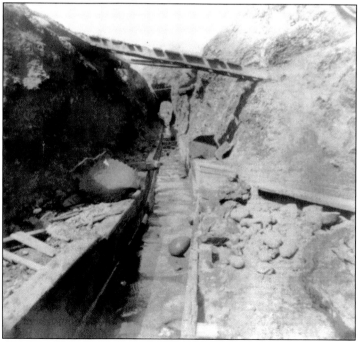

This tunnel at Timbuctoo contains a sluice down which material from the hydraulicking operations is washed. Often rocks were used to keep the water from lifting up the sluice blocks from below. According to Thompson and West, Quicksilver (mercury) was scattered in the tunnels to gather up the gold "as it is carried along with the mud and water." Many tunnels still lie beneath the surface of the land around Timbuctoo and Smartsville. (Courtesy Library of Congress.)

These sluice flumes at Timbuctoo are carrying material from the tunnels to the tailing "dumps" along the Yuba River. (Courtesy Library of Congress.)

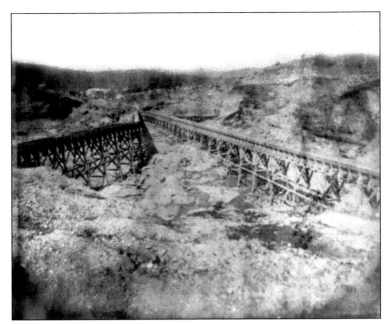

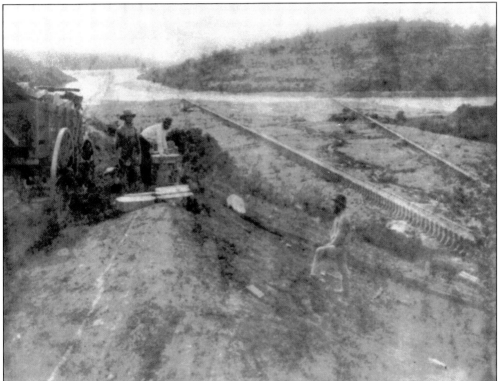

Pictured in 1866 is the end of the sluices from the Smartsville and Timbuctoo diggings—tail flumes emptying into the Yuba River. These operations contributed their share of slickens and debris, which, in addition to raising the riverbed by 80 feet in some places and causing flooding in Marysville, ultimately found its way to San Francisco Bay. Acres of peach, cherry, and apricot orchards became "cottonwood swamps . . . unfit for any useful purpose." (Courtesy Library of Congress.)

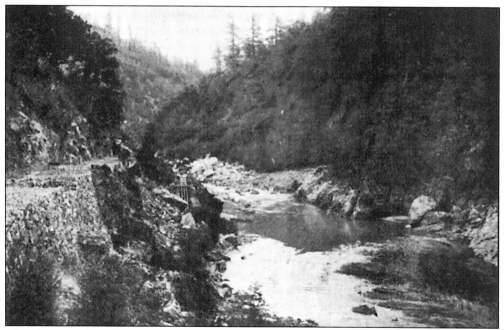

# THE WESTERN UNION TELEGRAPH COMPANY.

This Company TRANSMITS and DELIVERS messages only on conditions limiting its liability, which have been assented to by the sender of the following message. Errors can be guarded against only by repeating a message back to the sending station for comparison, and the company will not hold itself liable for errors or delays in transmission or delivery of Unrepeated Messages, beyond the amount of tolls paid thereon, nor in any case where the claim is not presented in writing within sixty days after sending the message.
This is an UNREPEATED MESSAGE, and is delivered by request of the sender, under the conditions named above.
THOS. T. ECKERT, General Manager. NORVIN GREEN, President.

| NUMBER | SENT BY | REC'D BY | | CHECK |
|---|---|---|---|---|
| | Sw X | 1 8 Paid | | |

Received at *Marysville, Cal* 9 26 am *June* 18 1882

Dated, *North San Juan June 18*

To *C E Saxey for The mayor*

English Resrvoir supposed
to be broken river very high
water now opposite Moores
Flat, look out for big Flood
H C Perkins

On June 18, 1883, the English Dam on the Middle Yuba River broke, sending 650 million cubic feet of water through the Narrows and toward mining settlements. The flood swept away flumes and bridges and drowned seven people and 40 animals. Marysville escaped flooding when a levee broke upstream from the city. H. C. Perkins, superintendent of the Bloomfield and Milton mining companies, suggested that the dam was blown up intentionally—a possibility in the tense years leading up to the Woodruff case. (Courtesy NARA Pacific Region.)

This photograph of the Narrows, taken in August 1905, shows the Yuba River at 2 inches above the low-water mark. (Courtesy Society of California Pioneers, San Francisco.)

Pictured is Judge Lorenzo Sawyer in 1890, a year before his death. Since his arrival in 1850, he had held jobs as a miner in the gold fields, a lawyer in Sacramento, a justice of the California State Supreme Court, and in early 1870 upon Pres. Ulysses S. Grant's nomination, U.S. Circuit Judge for the Ninth Circuit, embracing all Pacific states. (Courtesy Library of Congress.)

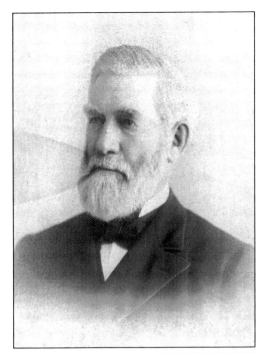

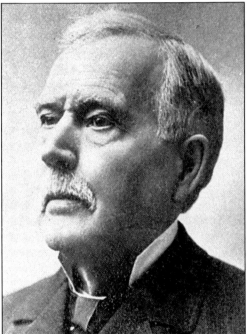

Isaac S. Belcher (left) and his brother William (right) were partners in a prominent Marysville law firm. Born in Vermont, Isaac came to California in 1853 and opened his law practice in Marysville. William joined him three years later. In *Woodruff v. the North Bloomfield Gravel Mining Company*, Isaac was one of the lawyers for the complainant, while William served among the lawyers for the defense. Isaac died in San Francisco in 1898; William died there in 1895. (Both courtesy Tammy L. Hopkins.)

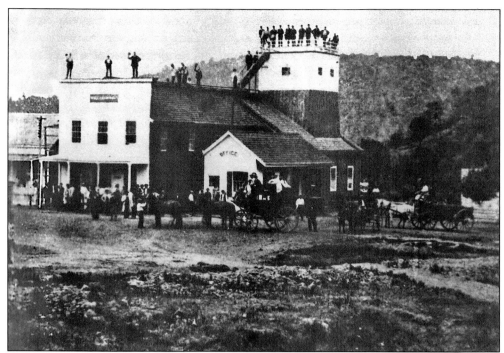

The Blue Point Mine in Sucker Flat was operated by Russell L. Crary. This complex located on the north rim of the channel, at the east end of town at the foot of O'Conner Hill, contained stage offices, a store, a saloon, a blacksmith shop, and even a building used as a theater for traveling shows. There was a bunkhouse for the single miners. The bunkhouse was home to some characters with colorful names such as Mustache Jack and the Judge. Payday at Sucker Flat was a big deal because it came only when they cleaned the sluices. The sluices were cleaned three times a year because it was a big job. Workers were lined up to collect their pay. After they paid their bill at the company store, they would be lucky if there was any money left. (Courtesy Bill Peardon.)

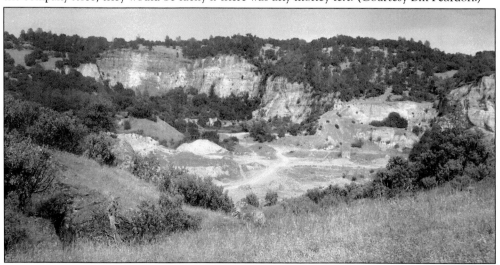

This 2007 photograph offers a view of an old mining site in Sucker Flat, perhaps an abandoned lead of the Blue Point Mine. Plans might one day be in the works to restore, as much as possible, the site to its natural state. (Photograph by Lane Parker.)

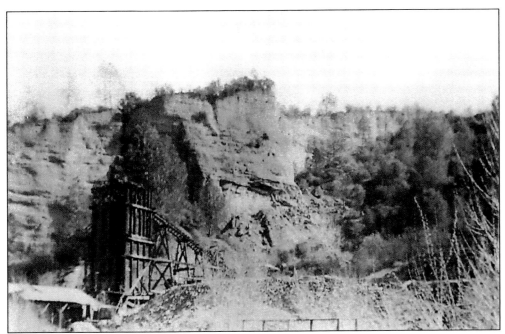

Shown is the head frame and ore bin of the Blue Point Mine in the old hydraulic diggings in Smartsville in the 1930s. The shaft runs from the head frame into the ground. Skips ran on tracks on the shaft and went 300 feet into the ground. There were three drifts going off of it. A drift is a little tunnel, also called a gangway. They went into the drifts to get the gravel to run through the mill. (Photograph by Asa Fippin; courtesy Rosemary Freeland.)

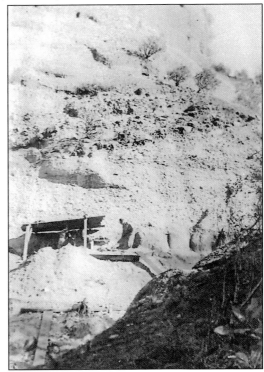

In a 1998 interview, Robert Fippin, the self-described last sucker born in Sucker Flat, said, "The face of the Enterprise Bank doesn't do justice to that Mooney Flat hill. It is a huge hill . . . not really a mountain, just a big long hill . . . and incidentally there is an untold fortune lying underneath that hill. But believe me there is a lot of dirt mixed up with it." (Courtesy Rosemary Freeland.)

In the early 1900s, two big events took place in Smartsville: one was the completion of Colgate Powerhouse and the other the Tarr Mine. The power lines of the Colgate Powerhouse ran through Smartsville with no access to the power. Not until the Tarr Mine was built did the town get electricity. This is the view of the entire complex of the Tarr Mine as seen from the hill on the Smartsville side. (Courtesy Mary Clark.)

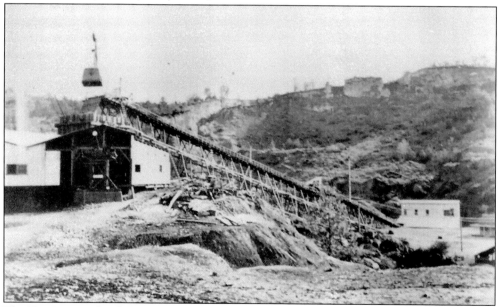

The Tarr Mine utilized the guidelines of the Caminetti Act to get around the stipulations of the Sawyer Decision. It was on the Blue Point claim. There was a stationary dredger, and the gravel was washed to a bucket line and then carried by conveyor belt to an ore bin on the rim of the channel. (Courtesy Mary Clark.)

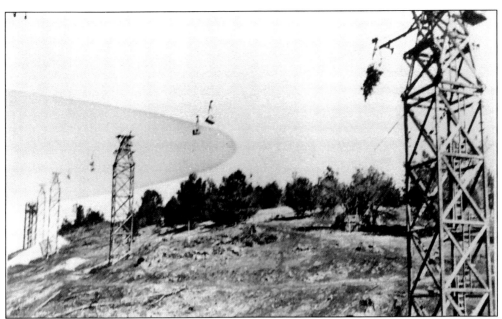

From the ore bin, the gravel was loaded into buckets in a system of aerial tramways. The tramway, seen above, consisted of 90 wooden towers with cables that carried buckets, which could dump anywhere along the line. They could dump the processed gravel where it would not go into the rivers. In 1907, Ernest H. Tarr started the project and was the major stockholder. During the time the complex was being built, there was an increase in the population of Smartsville. There were electricians, carpenters, and laborers. It was a temporary boost for the economy and the population. In the beginning of the mine, Tarr was known to ride his big black horse around overseeing the work, but later he was credited with bringing the first automobile to Smartsville. The photograph below was the concentrating plant of the Tarr Mine. (Both courtesy Mary Clark.)

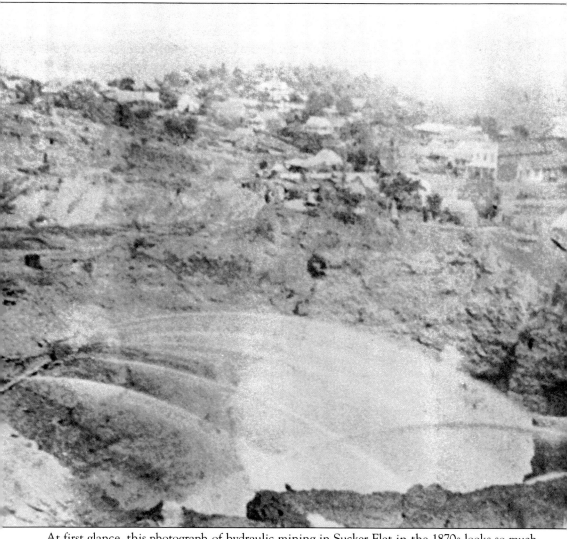

At first glance, this photograph of hydraulic mining in Sucker Flat in the 1870s looks so much like many others, but on closer observation the town of Sucker Flat can be seen on the top of the hill. Compare this image with the one on the top of page 76 and the Blue Point Mine complex can be recognized. (Courtesy Mary Clark.)

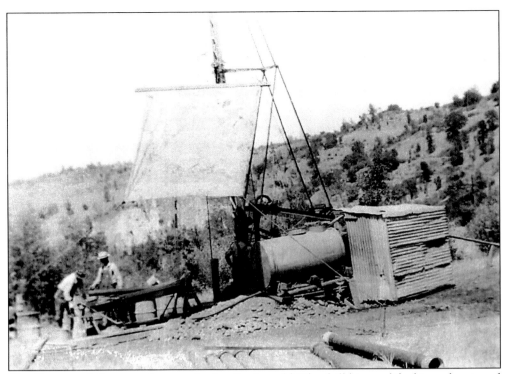

The Keystone drill was used to sample the dirt for gold. The drill bit was lifted into the air and let drop fast, and it churned a hole in the ground. They would put 8-inch cast-iron casings down to keep the hole from collapsing and drill down through the casings. Asa Fippin is seen operating it in the early 1930s. (Courtesy Rosemary Freeland.)

The Pelton wheel is a water-powered air compressor. The man operating the machine is Johnny Grace. Many people mentioned that he was an incredibly polite man and would bow and tip his hat whenever meeting anyone. (Courtesy Rosemary Freeland.)

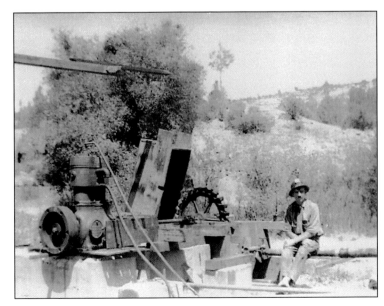

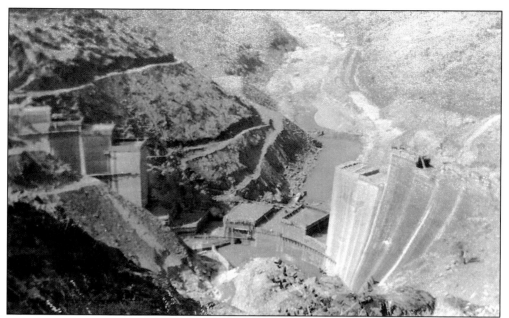

This shows the construction of Englebright Dam, which is located on the Yuba River just above the Narrows. At 1,142 feet across and 260 feet high, it was built to contain any remaining debris from mining from going farther into the rivers. It was named for Harry Lane Englebright, who was a mining engineer, was a native of Nevada City, and served in the U.S. House of Representatives from 1926 until his death in 1943. (Courtesy Rosemary Freeland.)

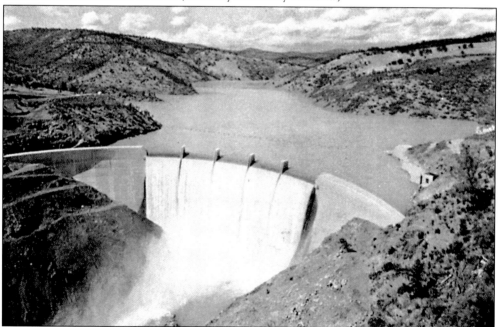

Today the Englebright Reservoir stores 45,000 acre-feet of water. It is a beautiful and popular recreation area for boating, fishing, and swimming. The reserved water is managed for domestic and agricultural purposes, as well as hydroelectric generation and for the benefit to fish and wildlife downstream. (Courtesy Leanna Poe Beam.)

# Five

# SMARTSVILLE
## GEM OF THE FOOTHILLS

As debris from hydraulic mining began to cover Roses Bar on the river, people moved to higher ground. With Timbuctoo and Sucker Flat already established, the next place was Smartsville, "the Gem of the Foothills." This was the claim made in the 1869 directory. Smartsville was known for being the pretty mining town with neat cottages and white-picket fences. The residents maintained flower gardens and fruit trees. It was civilization and community. Sure, it was the place where the miners could go to buy their supplies, have a drink at the saloon, get their mail, or have a good meal, but it was not just for them. It was home to the businesspeople and their families. It was a beautiful place to live. Subsequent directories boasted of the importance of the hydraulic mining and the richness of the mines. But if hydraulic mining hadn't been stopped, Smartsville may well have been the next victim of the slickens as it was completely surrounded by hydraulic mines. Ironically, ending hydraulic mining was the beginning of Smartsville's demise. While other forms of mining were employed and more expensive schemes were invented to get gold out of the hills, it became too costly and the mining stopped.

Many residents who wanted to stay turned to agriculture and ranching to make a living. Some families moved to Hammonton or Marigold to work for the dredging companies or went to work in the cities. Many young women went to nursing schools or college and stayed in the cities to work or get married. After these people left the area, there was always a soft spot in their hearts for "Dear Ole Smartsville." Many kept in close contact with their former town mates wherever they lived. Some sent their children to stay with their grandparents for the summers, and the children gained an appreciation for the old town. As many of those remaining in the town aged, they too moved to be near their children. Although the town goes on, it has never quite been the same.

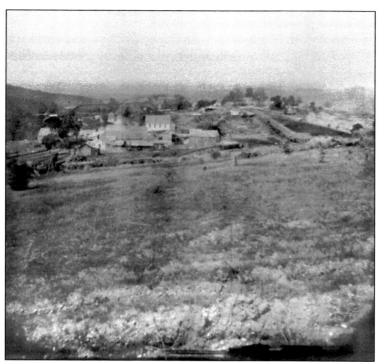

This hill in Smartsville is called Temperance Hill because it was the location of the Sons of Temperance lodge. The 1866 photograph above shows how the town was completely surrounded by sluices, flumes, and mines. Smartsville's hill was the next higher ground as hydraulic mining took off and the miners literally washed themselves out of house and home. Many took the opportunity to take part in the development of the new town. Buildings like the lodge and school were moved to escape the slickens. The grant for the town site of Smartsville was signed by Rutherford B. Hayes in 1878. The town was well established by then since it had been inhabited and was growing from 1850 as the area known as Empire Ranch. It became known as Smartsville in 1856 when James Smart built his hotel there. (Above, courtesy Library of Congress; below, Tammy L. Hopkins.)

84

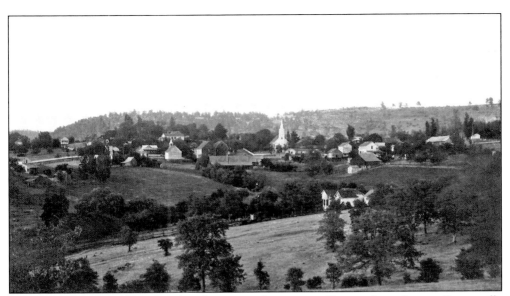

This c. 1880 photograph was used in the county directory to illustrate how pleasant Smartsville was. This bird's-eye view of Smartsville shows churches, homes, and businesses nestled in the foothills. (Courtesy Mary Clark.)

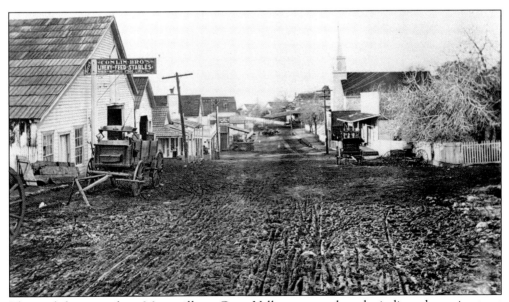

The road that went from Marysville to Grass Valley was rough and winding; the main street of Smartsville was the midway point. Today Highway 20 goes a little south of the old road, but during the early days, Smartsville was one of the stage stops on that well-traveled route. The wagon tracks can be seen in the road. It was said there were two seasons for the roads: mud and dust. (Courtesy University of California Davis.)

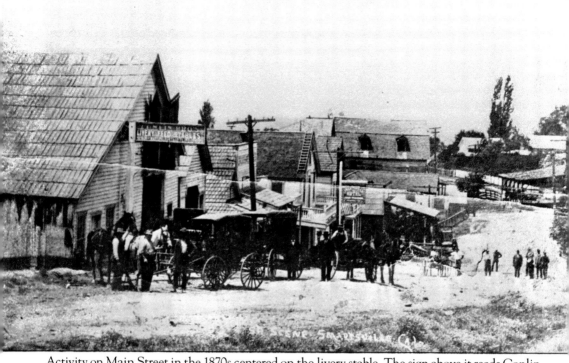

Activity on Main Street in the 1870s centered on the livery stable. The sign above it reads Conlin and Sons Livery Feed Stables. The Marysville and Nevada Stage stopped there to change horses and passengers. Lyman Ackley first owned the business later owned by Thomas Conlin. Conlin was a busy man by all accounts. He was the town constable, had the stable and the livery business, ran a stage line between Marysville and Nevada City, sold coffins, and arranged funerals. Looking just beyond the livery was the McConnell house and pharmacy, identified by a mortar and pestle on the roof. Margaret McConnell was the druggist. The drugstore had bottles of colored liquid, the usual pills and potions, and, of course, peppermint sticks, licorice, and rock candy. The next building with the ladder on the roof is the Smartsville Hotel. The sign hanging in front reads "Smartsville Hotel John Peardon Proprietor." The hotel was a two-story building with a long porch and balcony. (Courtesy University of California Davis.)

# SMARTSVILLE HOTEL,

## SMARTSVILLE, CAL.

### Offers Excellent Accommodations and Good Fare at Reasonable Prices.

The House is conveniently located near the Post-office, and possesses all the good qualities requisite in making the traveling public comfortable.

## JOHN PEARDON, Proprietor.

The advertisement for the hotel appeared in the 1884 directory. John and Elizabeth Peardon were natives of Cornwall and had seven children. Helen McGovern remembers her mother saying the Peardon girls had to leave school just before lunch so they could go serve the midday meal at the hotel. John was known as being a charitable man, taking in some Cornish miners who were too old to work because they were "boys from 'ome." (Courtesy Yuba County Library.)

Posing behind the bar of the hotel is John Peardon. A sign on the bar right next to the bottles of champagne advertises milk punch. Milk punch is a warm Irish beverage made of milk, whiskey, and sugar. Even though women were not allowed in the bar, there are two bouquets of flowers on the bar. (Courtesy Bill Peardon.)

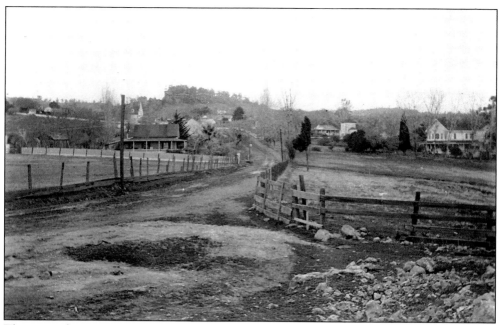

This view of Main Street from around 1895 was taken from a little farther up the street, which is uphill. One can see how the road curves as it comes into town. The white-picket fence seems to go on forever as it winds its way through town. (Courtesy Bill Conlin.)

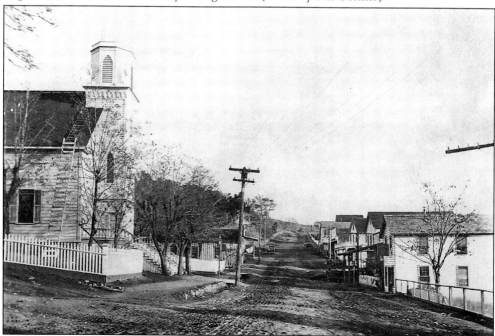

This photograph was taken around 1895 from the other end of town in the opposite direction. Buildings beyond the Smartsville Hotel are more visible. The sign on the first building on the right reads Dewans Hotel. The hotel first belonged to Mrs. Henderson and then to Allice Dewan and later to her daughter Lizie Beasley. Dewans did not have a bar and was more of a boardinghouse but did take in traveling guests. (Courtesy Bill Conlin.)

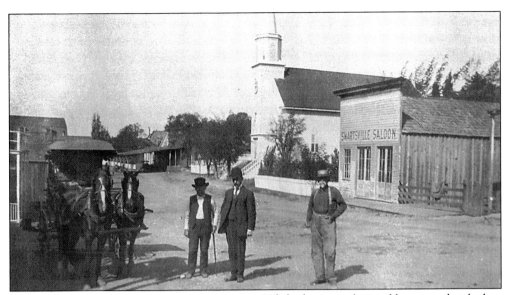

When a stage arrived, there was a lot of activity. While the stage changed horses and picked up mail, passengers could stretch their legs and have refreshments; men could go across the street to the Smartsville Saloon for a drink. Women and children were not allowed to enter the saloon; if they were traveling with a male companion, he could bring them a soda; if not, they could get a dipper of water from the faucet of the horse trough. John Dempsey, Jake Foreman, and William Bodecker are pictured with the Nevada Stage in October 1907. (Courtesy Bill Conlin.)

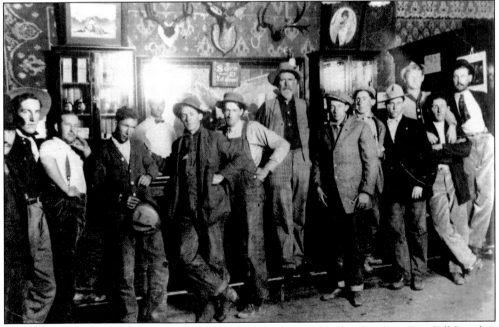

William "Baldy" Chamberlain started this saloon and named it the Excelsior Bar. Bill Peardon (behind the bar in 1908) owned and ran it as the Smartsville Saloon, which can also be seen in this image. He ran it until Prohibition at which time he went to Marysville and opened the Golden West Hotel. After Prohibition, the bar reopened as the Lucky Strike and was run for a long time by Elizabeth Williams. (Courtesy of Bill Peardon.)

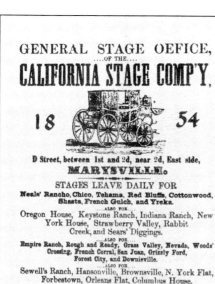

GENERAL STAGE OEFICE,
....OF THE....
CALIFORNIA STAGE COMP'Y,

18    54

D Street, between 1st and 2d, near 2d, East side,
MARYSVILLE.

STAGES LEAVE DAILY FOR

Neals' Rancho, Chico, Tehama, Red Bluffs, Cottonwood,
Shasta, French Gulch, and Yreka.
....ALSO FOR....
Oregon House, Keystone Ranch, Indiana Ranch, New
York House, Strawberry Valley, Rabbit
Creek, and Sears' Diggings.
....ALSO FOR....
Empire Ranch, Rough and Ready, Grass Valley, Nevada, Woods'
Crossing, French Corral, San Juan, Grizzly Ford,
Forest City, and Downieville.
....ALSO FOR....
Sewell's Ranch, Hansonville, Brownsville, N. York Flat,
Forbestown, Orleans Flat, Columbus House.
....ALSO FOR....
Wyandott, Miners' Ranch, Bidwell's Bar, and
Mountain House.
....ALSO FOR....
DRY CREEK, LONG BAR, PARKS' BAR, TIMBUCTOO, SMART-
VILLE, SUCKER FLAT, & EMPIRE RANCH.
AND EVERY MORNING AND EVENING FOR
Central House, Lynchburg. Oroville, Thompson's Flat,
Pence's Ranch, French Town, and Spanish Town.
————ALSO————
For SACRAMENTO, at 6 o'clock A. M. & 4 P. M. daily.
And arrive in time for the San Francisco boats.

Early stage lines were started by entrepreneurs who often literally had to make the road they would travel. They carried mail, gold coins, and perishables like milk along with passengers. The California Stage was one company offering service from Marysville. The trip from Smartsville to Marysville lasted between three and four hours. On December 27, 1881, a stage headed from North San Juan to Smartsville was robbed by 52-year-old Charles Bowles, better known as Black Bart. Page 16 offers a photograph of the California Stage Company's barn and stables. (Courtesy Yuba County Library.)

Pictured here on May 28, 1917, are Tom Conlin's son William and his wife, Clara, and their son William Jr. As the automobile was phased in, there was less and less business for the livery. The stage barn burned on September 3, 1918. William and Clara moved to Marysville, where William continued in the stage business using automobiles. (Courtesy Bill Conlin.)

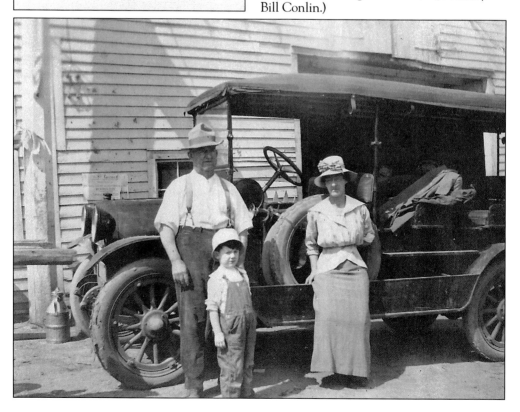

This historic building has been everything from the general store, post office, and Wells Fargo Express stop to an antique shop. It has been a men's dormitory for a Christian community and an apartment complex. At one time, it was the offices of the Excelsior Mining Company and at another the home and studio of sculptress Prudence Leach. (Courtesy University of California Davis.)

In its heyday, the Smartsville general store had everything in the way of hardware, housewares, soft and dry goods, and bought and transferred gold. The post office was in one corner, and the townsfolk would wait by the stove or sit on nail kegs for the mail. On the porch were benches where the old-timers would gather to tell stories and reminisce. (Courtesy University of California Davis.)

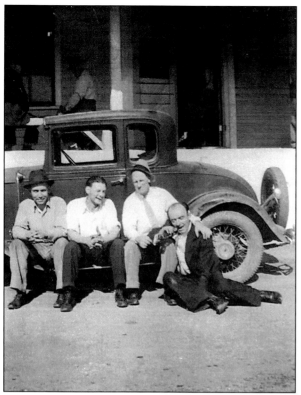

Four men pose in front of an automobile on a *c.* 1925 Sunday afternoon. On the running board in the middle is Jim Wheaton; the others are unidentified. They are in front of the Smartsville Store. A shed roof once covered the street and can be seen in some of the older photographs. Under the roof, there was a hitching post and a water trough for the horses. (Courtesy Rosemary Freeland.)

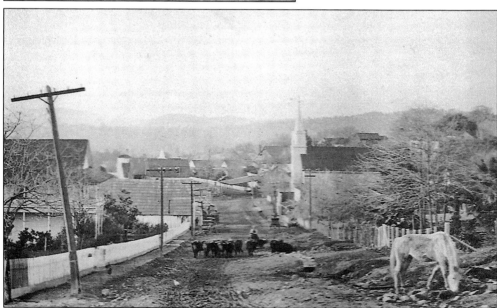

George Rigby said it was not unusual to see cows roaming the streets of Smartsville. He told the story of Harry Johnson, who was dressed in an all-white suit and Panama hat and was on his way to the saloon one evening. It was dark, and a cow happened to be sleeping under the shed roof of the store. Harry was walking along and didn't see her, and he tripped over her, making quite a mess of his fancy suit. This image is from around 1895. (Courtesy Mary Clark.)

Ada Peardon sent this postcard on February 27, 1912, to Rose Byrne, who moved to Marigold. "Dear Rose, I guess you know this place. I have been thinking of having Billy's take but he can not set up good enough suppose he would have to cry any way. Hope you are all well. Ada." Billy was Ada's six-month-old son. Ada was fatally burned later when warming milk for her baby and the alcohol burner overturned and caught her dress on fire. (Courtesy Kathleen Smith collection.)

The women of the town took pride in their homes and the luxuries they had, as is evidenced on the store ledgers. Wallpaper and other decorating items were stocked and purchased. Annie Chamberlain saw some importance in having this c. 1870 photograph of the mantle in her dining room made. (Courtesy Rosemary Freeland.)

James O'Brien was born May 28, 1830, and came to California in 1853. O'Brien spent several years mining at Bartons Bar before becoming interested in irrigation projects to supply the hydraulic power for mining. In 1858, he built Boyer Ditch from Deer Creek to Smartsville and the Excelsior ditch from South Yuba to Smartsville. In a partnership with San Francisco investors, he built the Pactolas Tunnel, owned one-half of the stock, and was superintendent of the mine. After the Sawyer Decision, as many in his position did, he concentrated mostly on agriculture and stock raising. He was married and the father of six. According to George Rigby, one of most amazing things is all these accomplishments were made without the ability to read and write. Rigby often wondered what more O'Brien may have accomplished if he had an education. (Courtesy YubaRoots.)

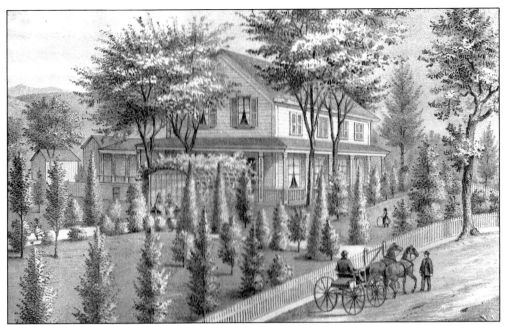

One of the larger homes belonged to James O'Brien. O'Brien was involved in mining operations but made much of his money building ditches. He hired Chinese laborers to build ditches and tunnels. He also hired them to build this home. It was said that he was fair in his dealings with them. The two Zelcova trees that frame the yard were a gift from some of his employees. (Courtesy YubaRoots.)

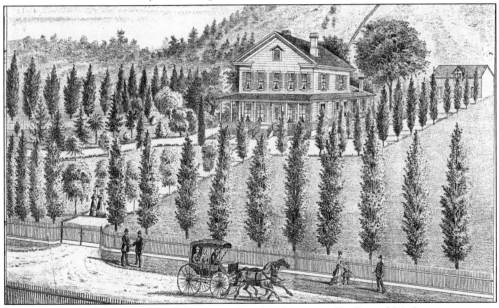

Pictured is the residence of another pioneer family of Smartsville. Daniel McGanney came to Smartsville from his native Ireland. After working in a few mining claims, he became involved in a number of businesses in the area, from a partnership in the livery with Tom Conlin to a partnership in the Blue Point Mine. He and his wife raised four sons and two daughters in Smartsville. The McGanney family cemetery is adjacent to the Smartsville Catholic Cemetery. (Courtesy Dave McGanney.)

Every summer, Edith Walsh, her sisters, and their mother would go up to Smartsville from San Francisco to visit their grandparents, William and Katherine O'Connor. They stayed in an old hotel along with her aunts and cousins who also made the trip. After the cold and fog of San Francisco, she loved the heat of Smartsville in the summer. In this 1933 photograph are, from left to right, Kathleen McFarland, Helen O'Connor, Edith Walsh, and Agnes Walsh. (Courtesy Kathy Donovan.)

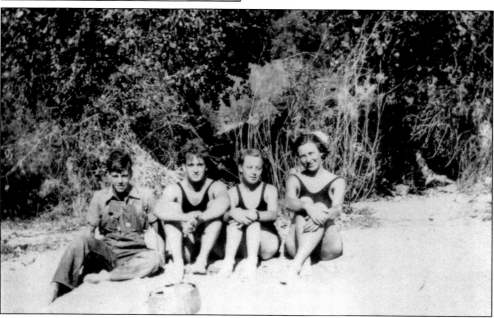

Edith Walsh often talked about swimming in an ice-cold lake in the area. The postmaster (possibly Jimmy Peardon) would deliver their mail and wouldn't make an effort to hide that he had read postcards they received; in fact, he would tell them any news before they could read it themselves. From left to right are unidentified, Joe McFarland, Helen O'Connor, and Edith Walsh around 1931. (Courtesy Kathy Donovan.)

Members of the O'Connor family posed for this photograph at one of the Smartsville summer reunions. From left to right are (first row) two unidentified people; (second row) Edith Walsh, Frank Grimes, May Walsh Grimes, Jack Malone, unidentified, Helen O'Connor, and William O'Connor. (Courtesy Kathy Donovan.)

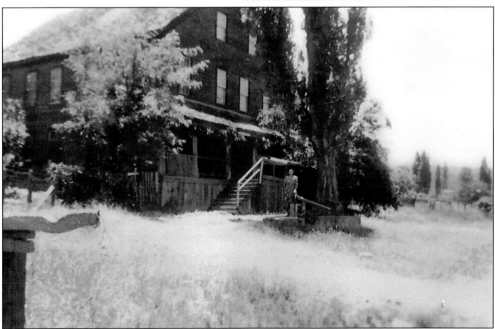

This photograph of the Mooney Flat Hotel was taken around 1922. The woman in front is Ida May Hite, granddaughter of the original owners, George and Veronica Schmidt. At that time, Hite was operating the hotel and it was used mostly for family vacations. (Courtesy Mary Clark.)

Contrary to the designation as California landmark no. 321, the little Smartsville Grocery was not the store and post office established by James Smart. It wasn't even built until the early 1930s when Agnes and Rex Alexander took apart the old Dewans Hotel board by board and built the store. They camped in this old barn that was downhill from the store. The Alexanders' daughter Christine poses with her dog in front of the store construction (below right). The store operated during the Depression and many people who had lost jobs and homes had come to the river to pan for gold and try to support themselves. The store purchased the gold so they could buy groceries. Members of the Maidu tribe also came to trade their gold and ordered large quantities of staple foods, which the Alexanders would order for them. Agnes Alexander (above) poses in front of the store for an article in the *Appeal-Democrat* in 2004. (All courtesy of Agnes Alexander.)

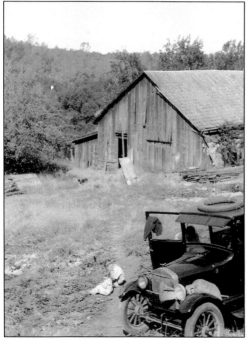

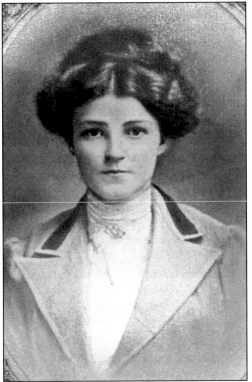
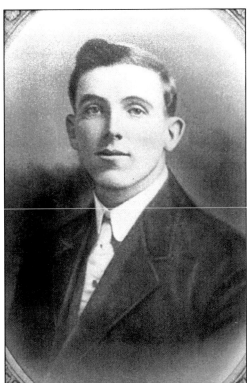

Pictured above are Emma Annabelle
Wheaton Fippin, born in Mooney Flat
in 1893, and Asa David Fippin, born in
Rough and Ready in 1885. They married
in Marysville in 1911; these portraits were
probably taken to commemorate that event.
The couple made Smartsville their home.
The photograph at right shows the couple
in the front yard of their Blue Gravel Road
home on Emma's birthday in 1967. The
old firehouse can be seen across the street
with the old truck inside. (All courtesy
Rosemary Freeland.)

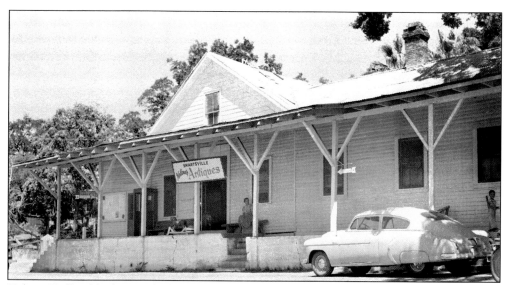

Helene Herlbut liked to say she bought the town of Smartsville. That is how it was advertised in 1958 in a Southern California newspaper; in reality, it was several buildings and vacant lots. One of the buildings was the former store and express stop, which Helene thought to be ideal for an antique store. She had an apartment on one side, her store in the center, and the post office was still at the other end of the building. Newspapers and television stations covered the story. Just as in the days of the general store, the old-timers came to sit on the benches in front of the new antique store and tell their stories. Just for fun, Helene, using nail polish, painted the names on the backrests of benches of those who sat on them. (Both courtesy University of California Davis.)

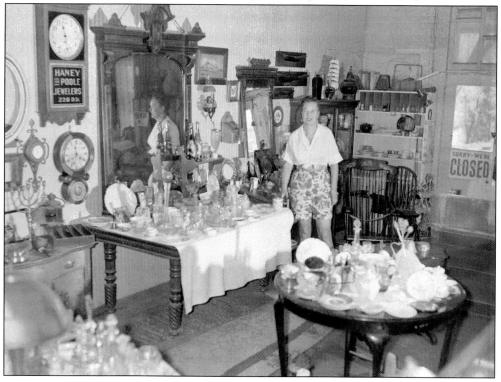

Helene had visions of making something grander out of Smartsville, more like Virginia City, Nevada. Unfortunately that didn't happen, and she left the town in 1964 when her husband became ill. She said the people were what she loved about the area. After living in many other places, she felt most at home in the foothills. (Courtesy University of California Davis.)

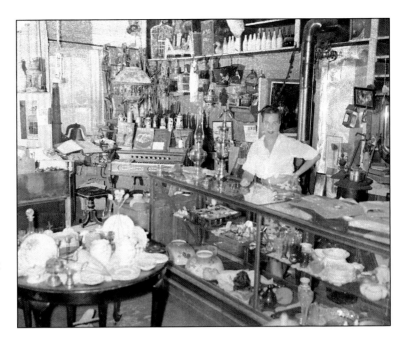

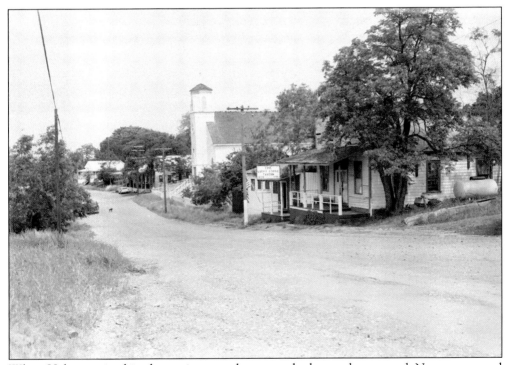

When Helene arrived in the rustic town the streets had never been paved. Newspapers and television stations from San Francisco to Sacramento covered the story. With all of the attention Smartsville received they finally had their roads paved. The Lucky Strike Tavern is in the same location as the Smartsville saloon seen on page 89. Note the livery and the pharmacy and hotel are now gone from the left side of the street. (Courtesy of University of California Davis.)

Is it Smartville or Smartsville? In 1910, the U.S. Postal Service decided "Smartsville" was not grammatically correct and should be "Smartville." A mountain of correspondence is evidence of the protest by citizens. The issue ended up involving attorneys, the California state librarian, and the U.S. Geological Survey as well as the post office, and when all is said and done, the powers that be decided on Smartville. Locals put the "s" in every time they get the chance. The fire trucks say Smartsville and "S" stickers can be seen between the *T* and the *V* on signs around town. If anyone refers to the place as "Smartville," locals will know they are not from there. The above photograph, taken in 1975, shows even the signs are ambiguous. The cartoon below is from the May 7, 1967, Sacramento *Union* edition. (Above, courtesy SAMCC; below, Yuba County Library.)

*Six*

# SMARTSVILLE
## DAYS GONE BY

Social organizations played an extremely important part in the development of the early Gold Rush towns, and Roses Bar Township was no exception.

Churches were organized to tend to the spiritual needs of the community. The first Catholic mass was held in Roses Bar in 1852. Priests would travel up from Marysville to serve mass to the community of mostly Irish immigrants. The Union Church was established in 1859 in Timbuctoo in a saloon that was renovated for the purpose. They held Protestant services on a rotating basis by visiting clergy. As the towns grew, church buildings were constructed and regular services were held.

The lodges provided members with a method of networking for business, forming partnerships and alliances, doing charitable works, and developing friendships. Roses Bar Lodge No. 89, Free and Accepted Masons, held its first meeting on August 1, 1855. Other lodges were also founded, like the Sons of Temperance and Fredonia Lodge, in the township during the early years. Roses Bar Lodge was active for well over 100 years, while the others existed only a short time. The logbooks survive today as written records of life in that time and place when little else does.

The Roses Bar Public School was organized in 1856 and was taught by Augusta Savage in that year and by Mrs. Berry from 1857 to 1872. At one time, Berry had as many as 72 students. There was also a private school taught by Miss Slayter and Miss Stevens. Their building was moved to Smartsville and became a private school taken over by Mrs. Berry. There were other private schools set up like that in Sucker Flat taught by Mr. Beasley. The Timbuctoo School was begun in 1856 and taught by Mr. Potter. The building was constructed in 1862 and in 1873 was moved to Smartsville and joined with Roses Bar School. The school continued to grow throughout the mining days and reached a high point of 200 students.

These organizations and others created a nicer community in which to live.

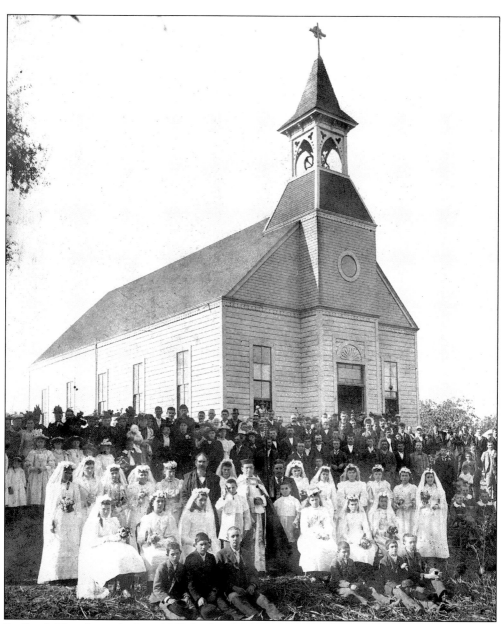

St. Rose's Church was built in 1862. Lacking a resident priest, the church was served by various priests from Marysville. It was a big day at the church when a visiting priest, or possibly the bishop, would come. Baptisms, first communions, confirmations, and maybe even weddings would be performed. St. Rose's was destroyed by fire in 1870. The church was so important to the parishioners that they pledged large sums of money for the immediate rebuilding. On June 7, 1870, the Marysville *Appeal–Democrat* reported $4,000 of the $6,000 the new building would cost had been pledged and a new foundation would be laid that week. The new building was completed in time for midnight mass on Christmas of the same year. (Courtesy Dutra-Hickeson family and Tammy L. Hopkins.)

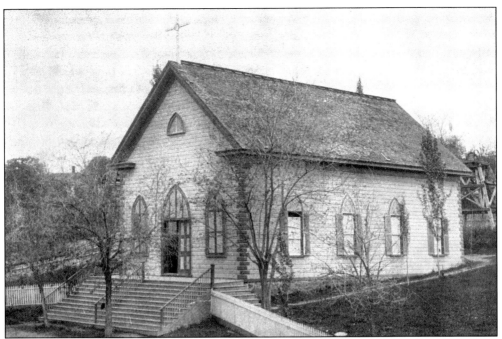

In 1871, the newly completed church was dedicated and named the Church of the Immaculate Conception. It was a plain building with no bell tower. The building materials of rough-sawn framing and hand-hewn trusses came from the area. Children planted cypress seedlings in the yard of the church. The bell was cast in 1878 in San Francisco and was hung on a frame behind the church. (Courtesy Smartsville Church Restoration Fund.)

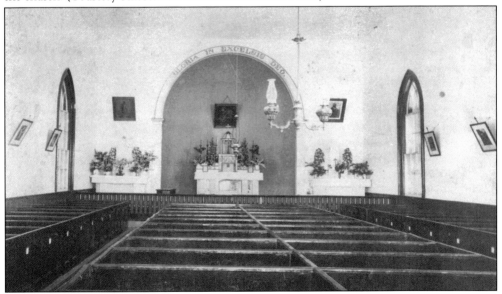

The interior of the church was beautifully furnished with box-style pews engraved with the names of the parishioners who donated to the rebuilding effort. At the front of the church, behind the altar, was a recessed curved and domed wall painted pale blue with the inscription above it in gold and black letters: *gloria in excelsis Deo*. The Stations of the Cross hang on the walls. (Courtesy Smartsville Church Restoration Fund.)

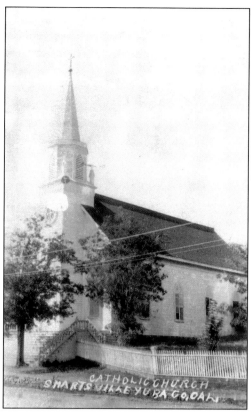

In 1895, the bell tower and steeple were added to the front of the existing building. The steeple made this a truly elegant-looking church. In 1939, strong winds damaged the steeple. For safety reasons, the bell was removed from the tower. (Courtesy Smartsville Church Restoration Fund.)

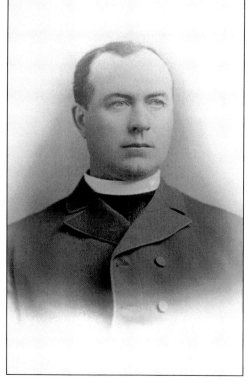

In 1873, Fr. Daniel O'Sullivan was named the first resident pastor at the Church of the Immaculate Conception. O'Sullivan remained until 1878. Mathew Coleman, pictured here, held the position from 1878 until 1887, when Fr. Andrew Twomey replaced him. (Courtesy Catholic Diocese of Sacramento archives.)

Fr. Andrew Twomey (right) was the resident priest from 1887 to 1902. He was the most beloved and popular priest the town ever had and was influential in establishing other churches in the outlying areas. Twomey traveled to surrounding communities to comfort the sick, administer last rites, and serve mass. One Sunday, he was bound for Rackerby when he tried to cross Dry Creek. Twomey's buggy overturned, and he was pinned in it and drowned. This was a terrible loss to the community, and they mourned and gave great tribute to this man who had meant so much to them. They erected a large monument to him at his grave site in the Smartsville Catholic Cemetery (below). The inscription reads: "Rev. Andrew Twomey a native of County Cork Ireland, Died March 8, 1902, aged 36 years, Erected by his loving flock and friends." (At right, courtesy Catholic Diocese of Sacramento archives; below, (photograph by Kathleen Smith.)

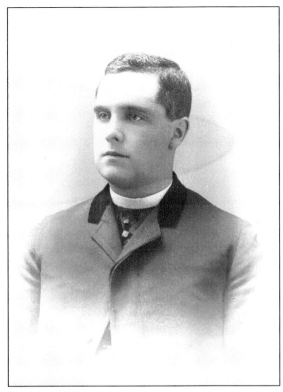

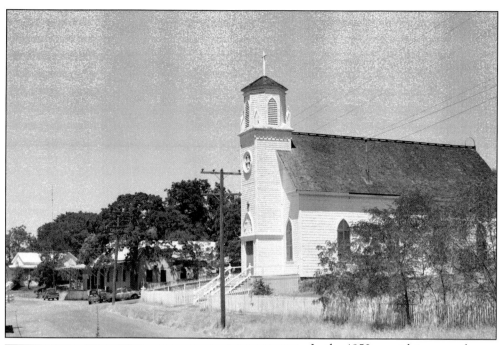

In the 1950s, parishioners and former residents spearheaded a successful effort to perform much-needed repairs to the old church. Although the building was returned to good condition, not even the increased publicity received during the restoration could help the dwindling attendance, and the church eventually closed. (Courtesy University of California Davis.)

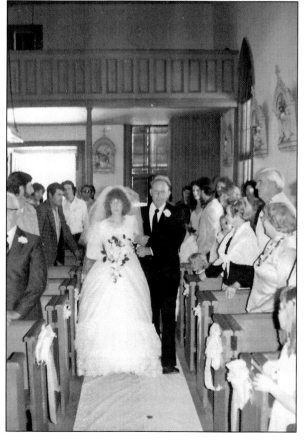

In 1989, Jerry Ann Pate wanted a church wedding. Her little community church was too small, so she requested use of the Church of the Immaculate Conception, which at that point had been closed for more than 10 years. She was granted permission on the condition she clean it. She and her party swept, mowed, scrubbed, and polished, and the old church never looked so good. (Courtesy Coralina Vance.)

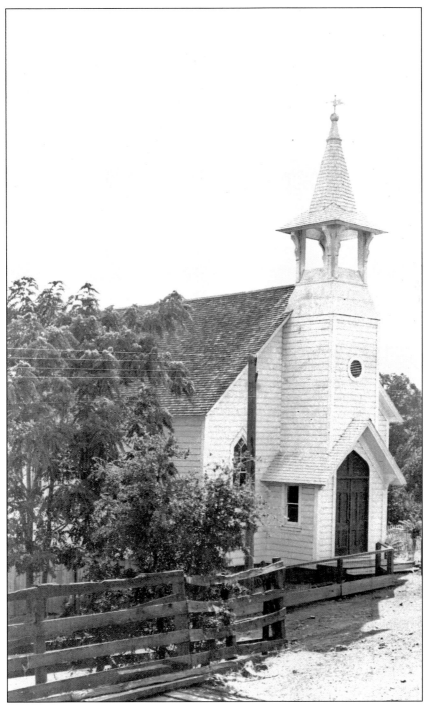

Built in 1863, the Union Church was used by the Protestant denominations and was the home of a Sunday school directed by John T. Vineyard. A fire destroyed the church in 1947, and the building was replaced with a surplus structure from Beale Air Force Base. A third incarnation of the church is still in use at the same site. The congregation is small but active. (Courtesy University of California Davis.)

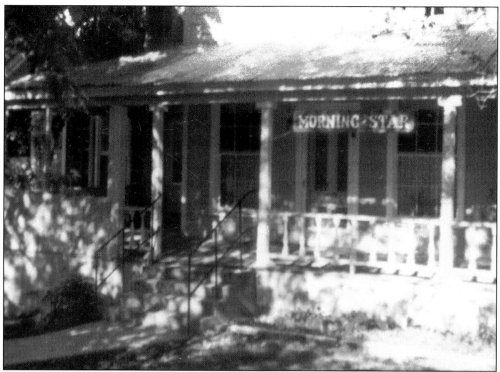

In December 1971, the congregation of the Community Church, co-pastored by Jerry Russell and Joe Rice, were praying for revival. The church decided to reach out to an influx of wandering young people some called hippies. There were some people squatting in the Timbuctoo area by the river, others just passing through; some were using drugs. The idea to pick them up and give them a meal, a place to stay, and the message of the church was well received. Soon the outreach turned into a full-fledged movement, and a Christian Community called Morning*Star was founded. Several parcels of property were combined to make the Morning*Star Ranch. They grew some of their food and raised animals for meat and started businesses to support themselves. The organization continued to grow, attracting youth from around the state. (Both courtesy Dave and Leslie Greenetz.)

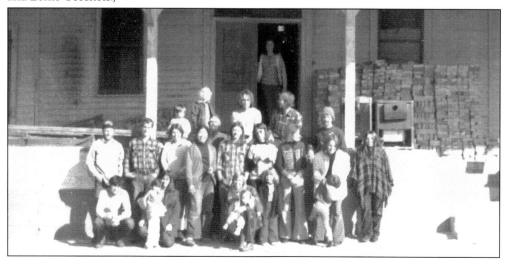

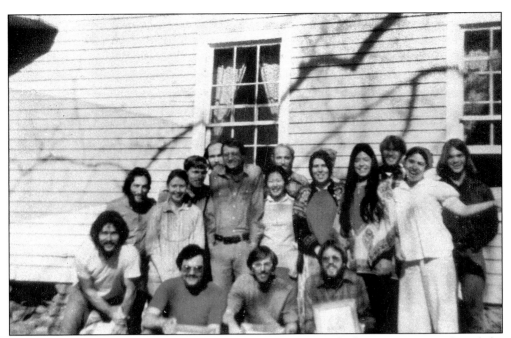

The organization renovated the James Smart Hotel property for living quarters and used the Excelsior store building as the fellowship hall and men's dormitory and another historic home for housing for married couples. It was nothing less than a phenomenon if anyone involved was asked. There were so many members, the little church could not hold them. During services, they would stand outside looking in the windows to be able to participate. As with many good things, they had to move on to grow so they built a church in Yuba City. Smartsville had once again lost a good chunk of its population. Many members still have a fondness for Smartsville; David Hobbs went as far as to say he felt Smartsville was his spiritual home. The photograph below is from around 1977. (Above, courtesy Dave and Leslie Greenetz; below, David Hobbs.)

111

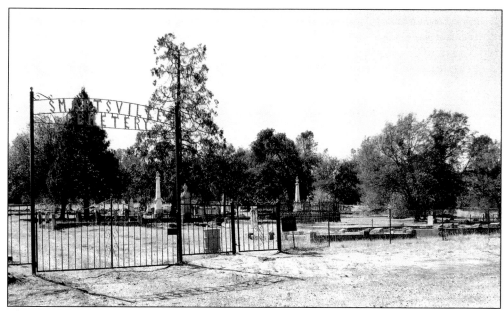

The cemeteries in Smartsville include the Smartsville Fraternal Cemetery (above), established by three fraternal organizations with land donated by Benjamin Sanford. Thompson and West state it was established in 1875; however, the earliest recorded burial is 1857. The Smartsville Catholic Cemetery (below) was established in 1864. Before this, Catholics were buried at St. Joseph Catholic cemetery in Marysville. There is a small private cemetery adjoining the Catholic grounds known as the McGanney Cemetery. There is also a small pioneer cemetery just across from Empire Ranch. There were originally 40 graves marked there, but it is unprotected and vandals have destroyed many of the headstones; now only about four are visible. When visiting these cemeteries, it is like visiting the old town itself. Almost everyone who had made this place his or her home is interred there. The headstones tell their stories. (Both courtesy YubaRoots.)

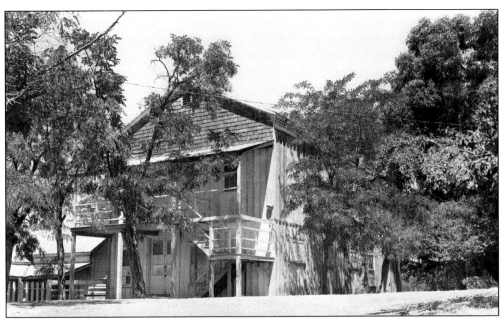

The Roses Bar Masonic Hall was the building moved from Roses Bar and was used not only for the activities of the lodge but for all kinds of community events, such as parties, dances, and wedding receptions. Even the Excelsior mining company rented the bottom floor. In 1989, the lodge moved its meetings to the lodge building in Yuba City and the Roses Bar building was sold. Shortly thereafter, it burned. (Courtesy University of California Davis.)

Shown is the installation of officers in 1961 of the Roses Bar No. 89 Free and Accepted Masons. Among the group are Asa Fippin (second from right) and Wendell Freeland (fourth from right). Rosemary Freeland, the granddaughter of Asa and daughter of Wendell, played violin for the installation. She also remembers going to the hall and playing the piano where she composed a song. Note that the photograph was signed by everyone except Wendell, as it was his photograph. (Courtesy Rosemary Freeland.)

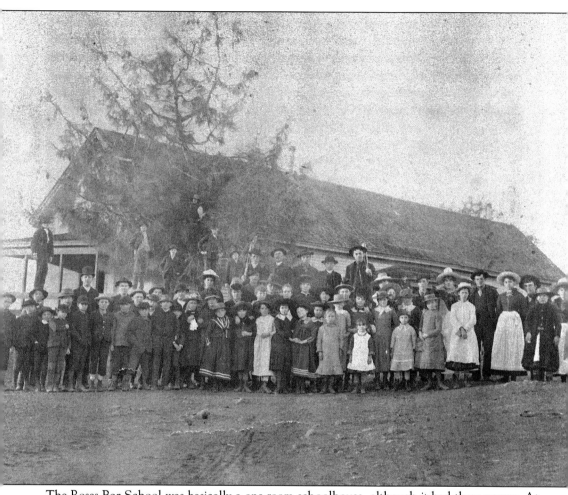

The Roses Bar School was basically a one-room schoolhouse, although it had three rooms. At one time, it accommodated as many as 200 children and three teachers. In the declining days, it had as few as 20 students. The old building was painted gray. This building burned down in 1936 and was replaced with a new one that was painted red. (Courtesy Bill Peardon.)

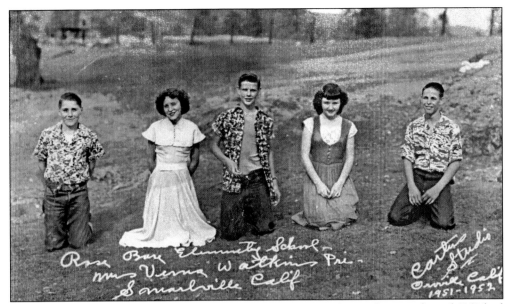

The class size of Roses Bar School dwindled with the town. This graduating class of 1952 had five students. The school was eventually closed and students were bussed to other communities for school. (Courtesy Jean Poe.)

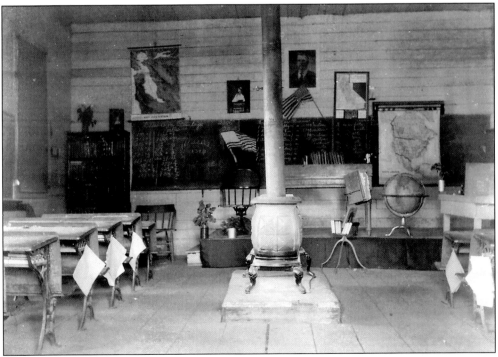

Pictured is the classroom of Roses Bar School. A portrait of Pres. Theodore Roosevelt above the chalkboard dates this photograph to the early 1900s. George Rigby described the aroma of the classroom as being of chalk, new and old books, lunches of salt pork and molasses cake, and the tar weed they walked through on their way to school. (Courtesy Mary Clark.)

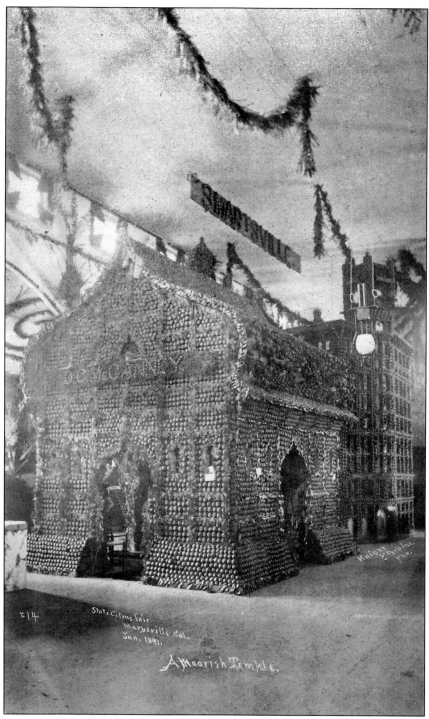

The community participated in state exhibitions such as the Citrus Fair in Marysville. Each participating town constructed a replica building out of citrus fruit. Local businesspeople sponsored the display. In Smartsville's Moorish Castle, the names of the sponsors—McGanney, Conlin, and O'Brien—can be seen on the building. (Courtesy Bill Conlin.)

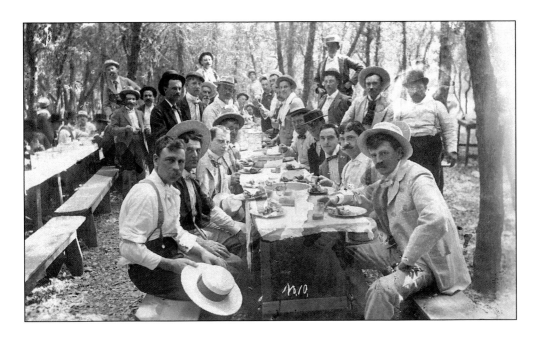

The Yuba Sutter Gun Club was modeled after one in Nevada County that would hold an annual dinner for its members. Ben Cockrill began the event in 1893, and it continued until 1898, each year becoming bigger and better. Up to 1,500 men attended. For weeks ahead, the members hunted for doves, ducks, and deer. "Old Abe" (Abraham Lewis) prepared the dove stew. All food and drinks were free, and there were plenty of appetizers. Shelton's Groves, acres of oak trees, was the location for this event. It lasted all day, and there were gambling games and prizes. At the last event, many of the attendees, after becoming highly intoxicated, began fighting, which got a little out of hand. The families of these men disapproved, and that was the end of the event. (Both courtesy Bill Conlin.)

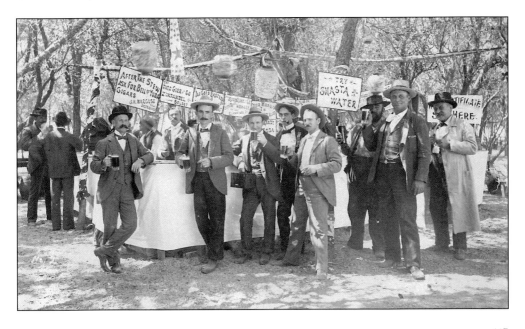

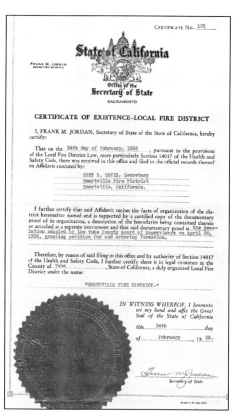

In the spring of 1946, a group of citizens met at Bud Schwartz's home and organized the Smartsville Volunteer Fire Department. The first chief was George Anderson. Jack Saunders was the first captain. On June 20, 1947, there was a devastating fire. It started when a transformer blew and caught one house on fire. Fifty-mile-an-hour winds spread it through town. When it was over, 11 buildings had been consumed. (Courtesy Smartsville Fire Protection District.)

Coralina Vance (the little girl on the left) remembers that day in 1947. Her mother, Esther Mitchell, was to make her monthly shopping trip to Marysville but felt uneasy, so she stayed home. When the fire broke out, she rounded up all the children and took them down into the diggings and lay in a ditch to escape the flames. They were not able to return to the town for three days. (Courtesy Coralina Vance.)

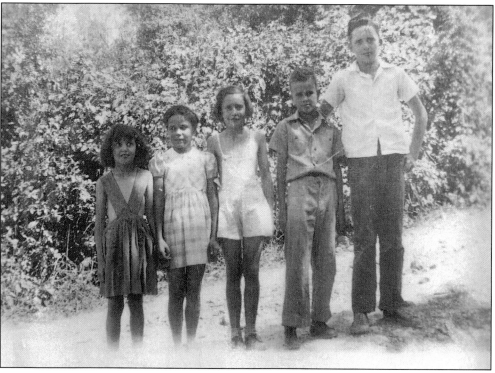

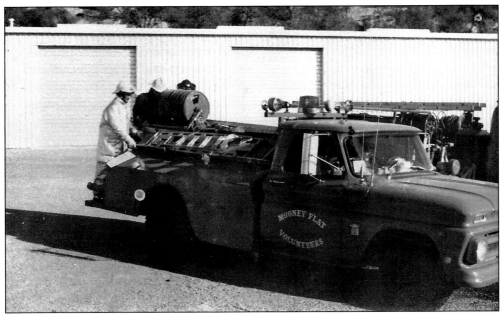

Many of the members of the Smartsville volunteers were from Mooney Flat; in turn, Smartsville covered that area. In 1950, Yuba County reorganized Smartsville, and the volunteers were no longer allowed to cross county lines for insurance reasons. This left Mooney Flat unprotected, so in 1977, the Mooney Flat Volunteers were formed. They bought equipment, attended training, and fought fires, but that was just half of it. They also had to raise money to run the department. Every year, they held a fund-raising fair with food, crafts, and games. They began publishing a newsletter, which became like the local newspaper. George Rigby began writing his stories for it. The organization included community togetherness as a goal. In 1989, they were annexed by the Penn Valley Fire Department, and a cooperative agreement now makes it possible for Smartsville Fire to respond to Mooney Flat. (Both courtesy Mary Clark.)

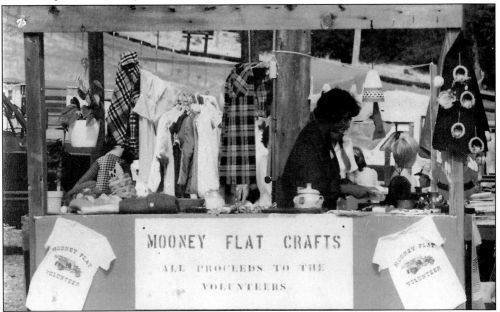

# GHOST TOWN RESTORATION
## OF TIMBUCTOO
### SUCKER FLAT - SMARTSVILLE, CALIFORNIA
# TENTATIVE PROGRAM

> BY PROCLAMATION, the Board of Supervisors, of the County of Yuba in the State of California, do hereby proclaim that since the true spirit of the Old West lies literally and figuratively in the Ghost Towns of Timbuctoo, Sucker Flat, and Smartsville that dot our landscape, we, the Board of Supervisors, proclaim that it is time to revive the traditions, the times and tenor of life as it existed when the West was young.
>
> By this proclamation we also proclaim that the day of Sunday, July 12, 1964 be that day on which all residents of California and environs, gather at the area of the three towns to once more live the life that made the West what it is today.
>
> YUBA COUNTY BOARD OF SUPERVISORS

**10:00 A. M. — SMARTSVILLE**

Pancake Breakfast

Modern Cowboy Lasoo Contest

Stage Coach and Covered Wagon Rides

Gold Panning and Sluicing Demonstration

Rock Cutting and Polishing

Historical Gun Display

Historical Records

Old-fashioned Telephone Demonstration

Flea Market

Tour - Prudence Leach Sculpture Studio

Chinese Historical Display and Demonstration

Historical Antique Auction All-Day at former J. P. O'Brien Home

**10:00 A. M. — HILLCREST**

Pony Express Time Trials Start for Men, Women and Children

**10:15 A. M. — SMARTSVILLE**

Central Sacramento Valley Shrine Club of Marysville, Drum and Bugle Corps

**11:00 A. M.**

Sacramento Chinese 60-Piece Band, Sponsored by Marysville Chinese Community. Band Concert and Drill Performers in Authentic Chinese Costumes

Arrival of $30,000 Gold Nugget Display, Largest individual collection in the Mother Lode Area (armed guards at all times).

Reunion Headquarters for former Smartsville Residents.

**12:00 NOON**

Band Concert by 12th District Naval Band.

Explanation of authentic map of rivers and type of gold found in each.

**1:30 P. M.**

Chinese Musical Group.

Gold Panning and Sluicing Demonstration.

**2:30 P. M.**

12th District Naval Band.

Gold Panning and Sluicing Demonstration.

Rock Cutting and Polishing

Tail-gate Swap of valuable rocks betwen rockhound members.

**3:00 P. M.**

Modern Cowboy Lasso Contest.

**4:30 P. M.**

Awarding of Pony Express winners, prizes, trophy and photo.

Drawing of Gold Dust winner and awerding of prizes to Gold Dust King and Gold Dust Queen.

**THERE WILL BE FOOD, SOFT DRINKS and BEER AVAILABLE ON THE GROUNDS**

Many efforts have been mounted to preserve what is left in the old mining towns. One event organized in 1964 was a daylong extravaganza, a cooperative effort by many community organizations. It included many exhibits, demonstrations, and contests. The reverse side of this flier appears on page 55. (Courtesy Yuba County Library.)

In July 1984, Red and Elva Farrell led the Smartsville Fun Day Parade on horseback. The caption reads, "Two real-life pioneers." To their community, they were much more than that. They were mentors to many youth and were an example of what is best about their community. (Courtesy Mary Clark.)

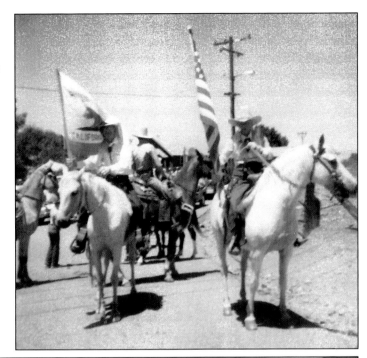

The Catholic Church deeded the Immaculate Conception Church building to the Smartsville Church Restoration organization, which is trying to preserve and eventually use it as a community center. They have raised some money and put on a new roof and shored up the foundation, but more needs to be done. The pews were removed and are being sold to raise funds. Currently the organization needs funds and skilled volunteers. (Photograph by Lane Parker.)

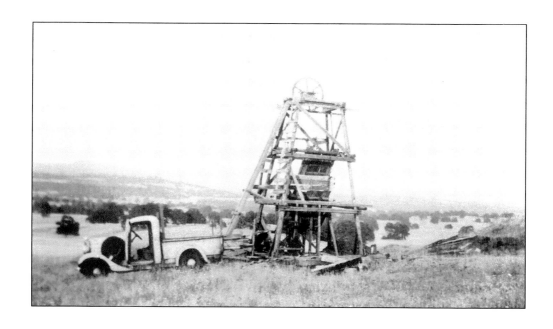

The Lone Tree area had been a popular mining area since the 1870s. Asa Fippin was operating this Lone Tree mine when it was taken by eminent domain for use as Beale Air Force Base. He wrote a letter to his congressman expressing his frustration with the handling of compensation. For him, it was about losing his livelihood, but for others it was more personal. They were giving up land they had worked and lived on for many generations. Above is the head frame of the mine; below are Sidney and Jess Fippin, sons of Asa Fippin. (Both courtesy Rosemary Freeland.)

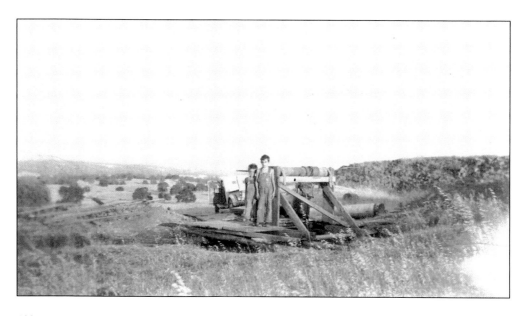

Red and Elva Farrell had to give up the land that Elva's grandfather drove his cattle to from Kentucky in 1884. They were fortunate to replace it with 1,400 acres in Mooney Flat they named Keystone Ranch. The land included buildings that had been used for a mess hall and dormitories for the workers building the Englebright Dam. Some of those buildings are still in use by the family. In the photograph above is Red Farrell with some of the ranch in the background. There has now been another five generations of their history in the area. The current generation is now following family tradition to produce naturally raised, grass-fed beef and lamb. When asked why she continues ranching, Kim Salas says she grew up there and loves the animals. It is her turn now to continue this tradition so it can be passed on to her children. (Both courtesy Kimberly Salas.)

Above was the home of Daniel Dougherty, a native of Ireland who brought his bride there in 1856. He had a store in Sucker Flat, which was originally called Gatesville after a man named Gates. After he left, they called it Sucker Flat because Gates had been from Illinois, which was nicknamed the Sucker State. The house itself was rumored to have been built by John Rose. It is the only house remaining in Sucker Flat where once hundreds were. It was also the birthplace of Ida Dougherty Rigby, mother of Joe and George Rigby, pictured below. George Rigby, the "Sage of Smartsville," did what so many only think about. He sat down and wrote little stories of his memories and his thoughts. George lived there until 1946, when he built his house in Smartsville. The man on the horse is Mr. Whorl. (Both courtesy Nora Compton.)

George Rigby, seen in both images, attended the Roses Bar School. He wrote about hanging out around the livery as a child and dreaming of being a horse trainer. Mostly he wrote about the people and places of Roses Bar. He wrote about what he remembered learning from listening to the stories of the elders and what he observed. They are not fancy stories, but no images could substitute for the descriptions of the personalities, sights, sounds, and aromas of that time that he put on paper to be preserved. George also had a hobby of leatherwork and made saddles. In the photograph above, George is on his horse. When asked how he would like to be remembered, he replied, "He made a saddle and wrote a book," which is the title of his book. (Both courtesy Nora Compton.)

# SELECTED BIBLIOGRAPHY

Bal, Peggy. *Pebbles in the Stream: A History of Beale Air Force Base and Neighboring Areas*. Nevada City, CA: Nevada County Historical Society, 1979 and 1993.

*Daily Appeal* (Marysville)

Delay, Peter J. *History of Yuba and Sutter Counties*. Los Angeles, CA: Historic Record Company, 1924.

Ellis, W. T. *Memories: My Seventy-Two Years in the Romantic County of Yuba California*. Eugene, OR: The University of Oregon, 1939.

*History of Yuba County, California with Illustrations*. Oakland, CA: Thompson and West, 1879. (Rep. Volcano, CA: California Traveler, 1970.)

Isenberg, Andrew C. *Mining California: An Ecological History*. New York: Farrar, Strauss, and Giroux, 2005.

Litchfield, M. Letitia. "A Brief History of Smartsville, Timbuctoo and Vicinity," *Bicentennial*. Marysville, CA: Yuba County Historical Commission, 1976.

McDannold, Thomas A. *California's Chinese Heritage: A Legacy of Places*. Stockton, CA: Heritage West Books, 2000.

Moody, Ralph. *Wells Fargo*. Lincoln, NE: Bison Books, 2005.

Ogden, Annegret. "Born in Timbuctoo: The Voice of Eveline Brooks Auerbach, Part 1." *The Californians* Vol. 11, No. 1: 6, 7, 38–45.

Ramey, Earl. *Beginnings of Marysville*. San Francisco, CA: California Historical Society, 1936.

Rigby, George. *He Made a Saddle and Wrote a Book*. Penn Valley, CA: The Villager, 1984.

*Sacramento Bee*

*Union* (Nevada County)

Wyckoff, Robert M. *Hydraulicking North Bloomfield and the Malakoff Diggings State Historic Park*. Nevada City, CA: self-published, 1999.

# INDEX

Ashenbrenner, Jim, 44, 64
Auerbach, Eveline (Brooks), 32
Barrington, George, 28–31, 49
Beale Air Force Base, 2, 55, 109, 122
Belcher (Isaac S. and William C.), 75
Black Bart, 7, 49, 90
Bonanza Ranch, 2, 44
Brooks, Noah, 7, 26
Conlin, Thomas, 86, 90, 95, 116
Cosgrove, John, 38
Dufford, Jacob, 24, 28, 29
Empire Ranch, 2, 7, 9, 12, 14–17, 84, 112
Englebright Reservoir, 2, 8, 82, 123
Excelsior Water and Mining Company, 67, 91, 94, 113
Fippin, Asa, 8, 55, 77, 80, 81, 99, 113, 122
Gordon, James, 26, 47
Gruber, William "Wild Bill," 8, 43, 45, 60, 63
Gunning, Samuel O. Jr., 8, 55, 60
Gunning, Samuel O. Sr., 66
Hapgood, Eugene "E. D.," 34
Herlbut, Helene, 100, 101
Marple, William "Bill," 23
Marysville, 2, 8, 16, 26, 29, 33, 34, 37, 41, 47, 48, 52, 73, 74, 75, 85, 86, 89, 90, 99, 103, 104, 112, 116, 118
McCarty, Matthew, 8, 63
McGanney Cemetery, 2, 112
McGanney, Daniel, 95
McGovern, Helen, 37, 87
McQuaid, Bob, 38
Melbourne, Henry C., 26, 59
Mooney Flat, 2, 7, 22, 77, 97, 99, 119, 123
Mooney, Thomas, 9, 15, 16
Narrows, The, 2, 74, 82
Native Daughters of the Golden West, 47, 52, 56

O'Brien, James, 38, 94, 95
Parks Bar, 2, 7, 8, 18, 19, 20
Parks Bar Bridge, 2, 20, 21, 34, 54
Parks, David, 9, 18
Peardon, John, 86, 87
Rigby, George, 8, 92, 94, 115, 119, 124, 125
Rose, John, 9–11, 25, 124
Roses Bar, 2, 7, 9–14, 16, 18, 23, 25, 34, 65, 67, 83, 103, 113, 125
Roses Bar Lodge, 12, 24, 103
Sacramento, 8, 9, 25, 45, 46, 75, 101
Sand Hill, 2, 7, 23, 37
San Francisco, 9, 11, 24, 37, 54, 73, 75, 94, 96, 101, 105
Sanford Creek, 2, 46
Sawyer, Lorenzo, 65, 71, 75
Sawyer decision (*Woodruff v. North Bloomfield Gravel Mining Co.*), 7, 65, 75, 78, 94
Smart, James, 7, 84, 98
Smartsville Catholic Cemetery, 2, 43, 95, 107, 112
Smartsville Fire Protection District, 6, 118
Smartsville Masonic Cemetery, 2, 36, 112
Spect, Jonas, 9, 65
Stewart (Abe and Sam), 30, 47, 59
Sucker Flat, 2, 7, 14, 68, 76, 77, 83, 103, 124
Tarr Mine, 78, 79
Timbuctoo Bridge, 2, 40, 41, 46
Timbuctoo Cemetery, 2, 25
Timbuctoo Ravine, 2, 9, 23, 44, 46, 62
Twomey, Fr. Andrew, 106, 107
Walsh, Edith, 96, 97
You, Suey, 33, 47
You, Tong, 33
Yuba Sutter Gun Club, 117

# DISCOVER THOUSANDS OF LOCAL HISTORY BOOKS FEATURING MILLIONS OF VINTAGE IMAGES

Arcadia Publishing, the leading local history publisher in the United States, is committed to making history accessible and meaningful through publishing books that celebrate and preserve the heritage of America's people and places.

Find more books like this at
**www.arcadiapublishing.com**

Search for your hometown history, your old stomping grounds, and even your favorite sports team.